Floral
Inspirations

A Collection of Drawing and Painting Ideas for Artists

Includes work in:
- Acrylic
- Colored Pencil
- Oil
- Pastel
- Watercolor

First published in the United States of America by:
Quarry Books, an imprint of
Rockport Publishers, Inc.
33 Commercial Street
Gloucester, Massachusetts 01930-5089
Telephone: (508) 282-9590
Fax: (508) 283-2742

Distributed to the book trade and art trade in the United States by:
North Light, an imprint of
F & W Publications
1507 Dana Avenue
Cincinnati, Ohio 45207
Telephone: (800) 289-0963

Other Distribution by:
Rockport Publishers, Inc.
Gloucester, Massachusetts 01930-5089

ISBN 1-56496-385-3

10 9 8 7 6 5 4 3 2 1

Designer: **Frederick Schneider / Grafis**
Cover Images: see pages 33, 39, 44, 50, 56, 66

Printed in Hong Kong.

Floral Inspirations

A Collection of Drawing and Painting Ideas for Artists

QUARRY BOOKS

ROCKPORT PUBLISHERS, INC. • GLOUCESTER, MASSACHUSETTS

DISTRIBUTED BY NORTH LIGHT BOOKS • CINCINATTI, OHIO

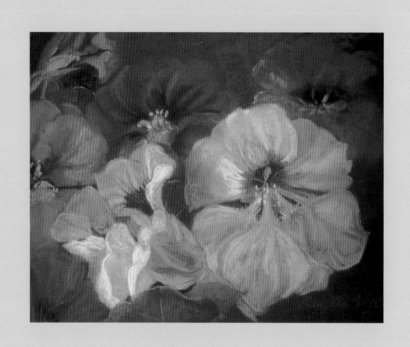

Introduction

A flower is a part of nature that begs to be captured in some form: photographs, pressed flowers, drawings, and paintings. With their intricate beauty, it is hard to resist the urge to bring them home with you. This volume is a chance to do just that–you will find many types of flowers rendered in various styles in this book.

Flowers transcend all boundaries of painting technique: they can be rendered in any style, in any media, on any type of paper, and still produce stunning results. Flowers offer the ultimate opportunity in a painting: they are full of color and detail, they come in every possible shape and size. With this many choices, the same flower in the same position offers an abundance of painting possibilities.

Every artist's eye is different. When a painter looks at a flower, it may be just at the form, or the color, or the shape. It may not even be an actual flower; it may be pulled from the vision in an artist's head. Flowers offer an excellent opportunity to experiment with technique. With their varied texture, intricate details, natural composition, and interesting color, each artist can use flowers to investigate what their paint and their painting has to offer. Every artist has a personal method that produces the best result: flowers are the universal subject in the presentation of that style.

Though the styles may vary, each of the paintings in the volume manages to capture the essence of flowers. By flipping through the pages, you can almost smell their beautiful fragrance. The fields of flowers appear to sway in the breeze, while close-up views show the intricate makings of a flower. Whether rendered in rich oils or pale watercolors, each artist has saved a touch of nature's beauty for our own enjoyment. We hope this volume will offer inspiration for your own painting, whether in style, technique, or media, and show you all that floral painting has to offer.

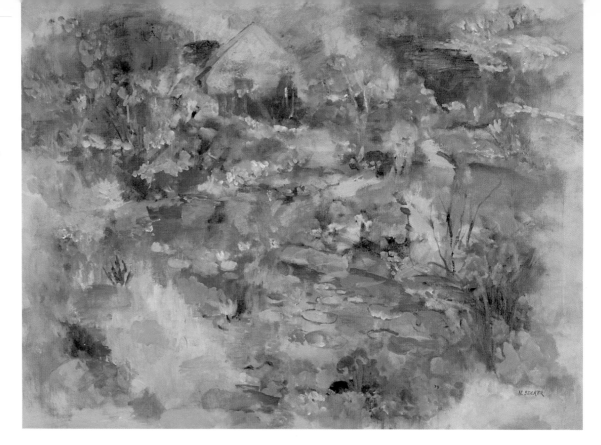

Natalie Becker
Spring Garden
28" x 36" (71.1 cm x 91.4 cm)
Belgian linen canvas

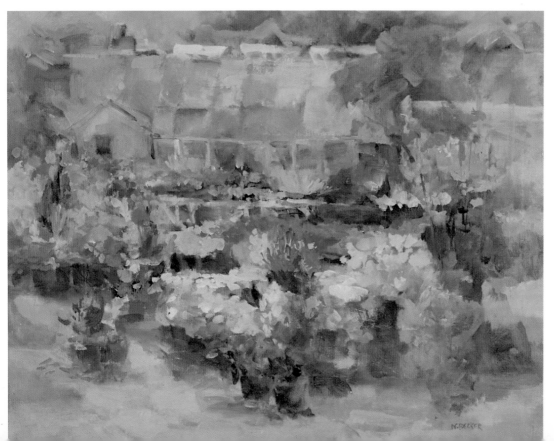

Natalie Becker
Florist's Garden
24" x 30" (61 cm x 76.2 cm)
Belgian linen canvas

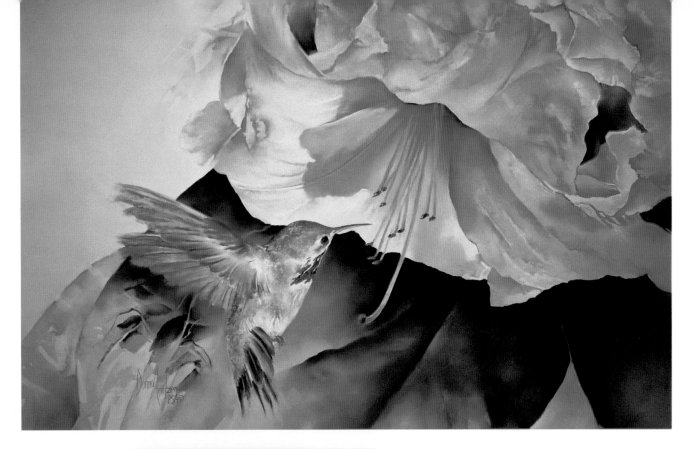

Donna L. Arntzen
Garden Gem - Calliope
15" x 20" (38.1 cm x 50.8 cm)
*German Ersta fine-buff 7/0 grit
sanded pastel paper*

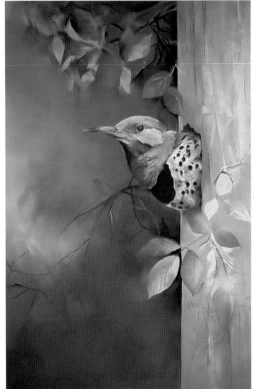

Donna L. Arntzen
Watchful Eye - Northern Flicker
20" x 15" (50.8 cm x 38.1 cm)
*German Ersta fine buff 7/0 grit
sanded pastel paper*

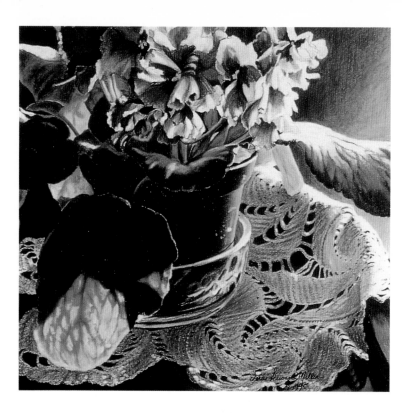

Vera Susan Miller
Afternoon Sun
20" x 20" (51 cm x 51 cm)
Museum board

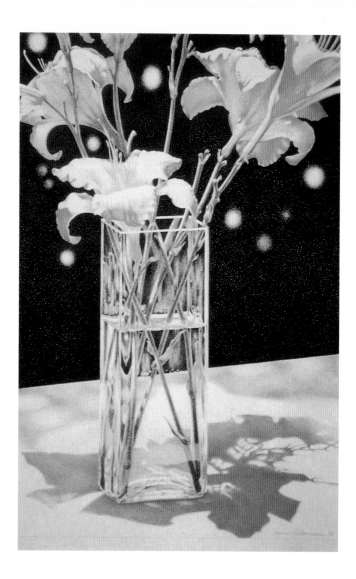

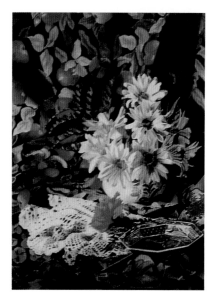

Deane Ackerman
Daylilies
20" x 22" (51 cm x 55 cm)
Strathmore 80 lb. paper

Wendy Nelson Ackerman
October's Flowers
24" x 20" (61 cm x 51 cm)
Lenox 100% rag printing paper

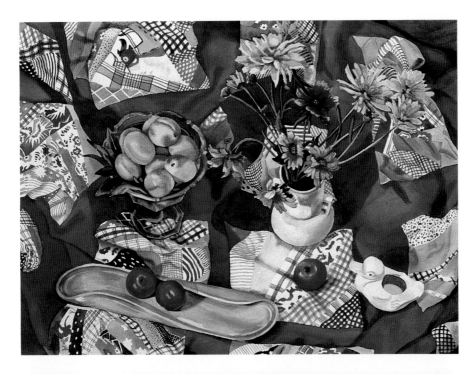

Maxine Yost
Still on Crazy Quilt
22" x 30" (55.9 cm x 76.2 cm)
Arches 300 lb.

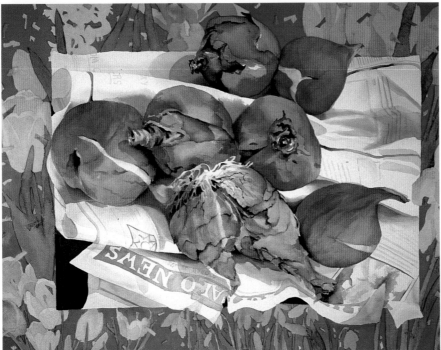

Susan Webb Tregay
They're Not Onions
22" x 30" (55.9 cm x 76.2 cm)
Arches 140 lb. cold press

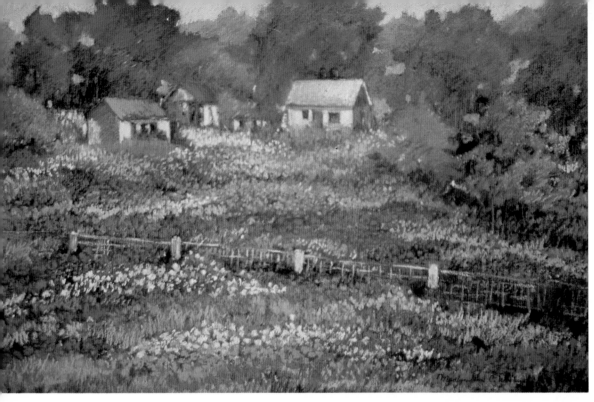

Madlyn-Ann C. Woolwich
Flower Hill
22" x 28" (55.9 cm x 71.1 cm)
Pastel with acrylic
Gesso- and pumice-treated
8-ply museum board

Alice Bach Hyde
Southern Spring
21.5" x 26.5" (54.6 cm x 67.3 cm)
Ersta Starcke 7/0 grit pastel
sandpaper

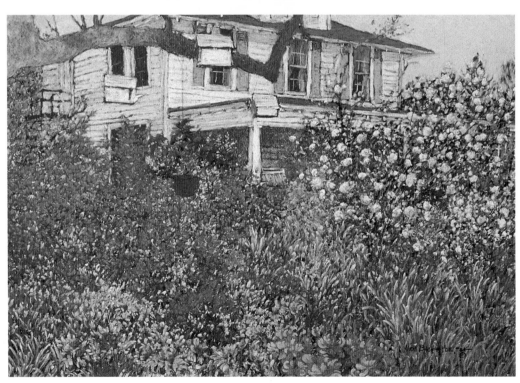

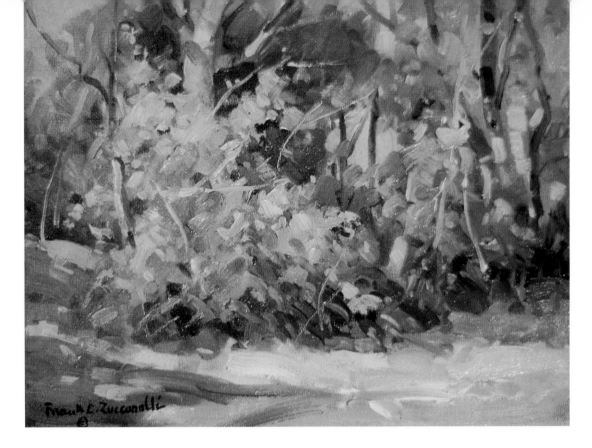

Frank E. Zuccarelli
October Hickory
8" x 10" (20.3 cm x 25.4 cm)
Canvas

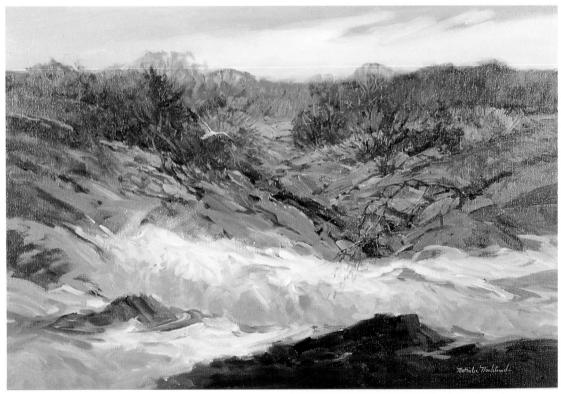

Nathalie J. Nordstrand
Autumn at Folly Cove
24" x 36" (61 cm x 91.4 cm)
Linen

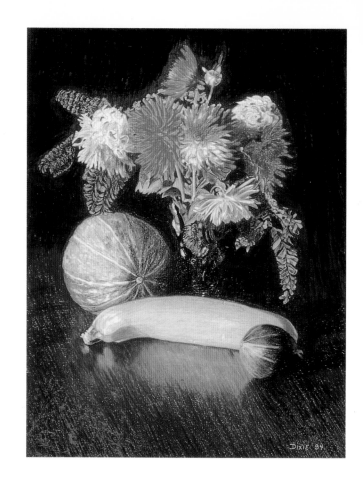

Dixie Smith
Dahlias and Squashes
28" x 21" (71 cm x 53 cm)
Rising Stonehenge

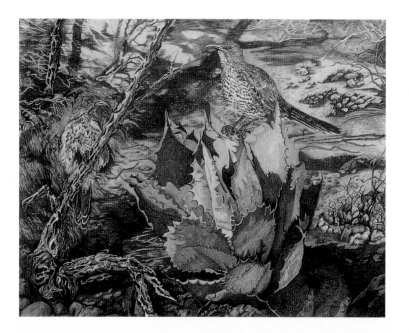

Donna Gaylord
Curved Bill Thrashers
29" x 35" (74 cm x 89 cm)
Bristol board vellum

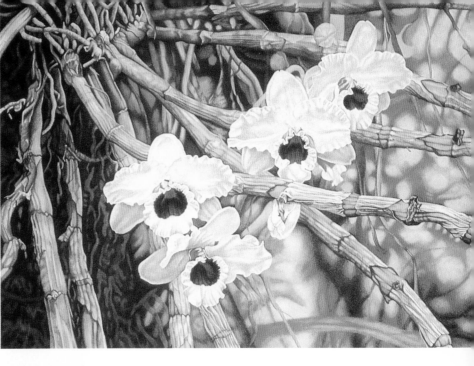

Katharine Flynn
Primal Garden
22" x 27" (56 cm x 69 cm)
Strathmore 500 Series 4-ply

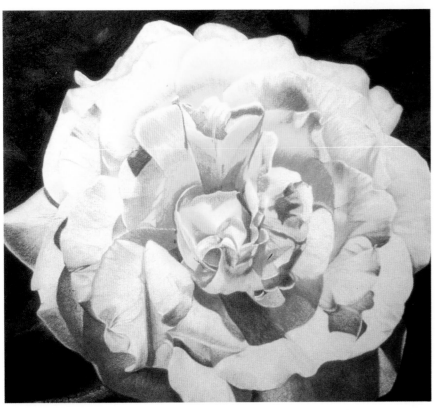

D. Thornburg James
Rose Explosion
24" x 26" (61 cm x 66 cm)
Arches hot press

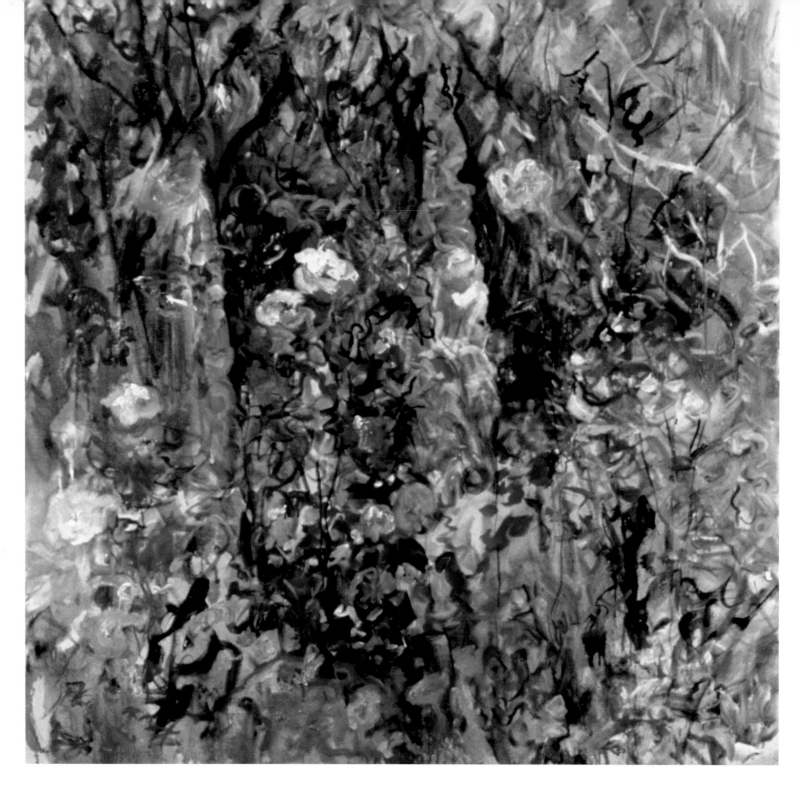

Gloria Moses
Garden Series #10
48" x 48" (121.9 cm x 121.9 cm)
Canvas

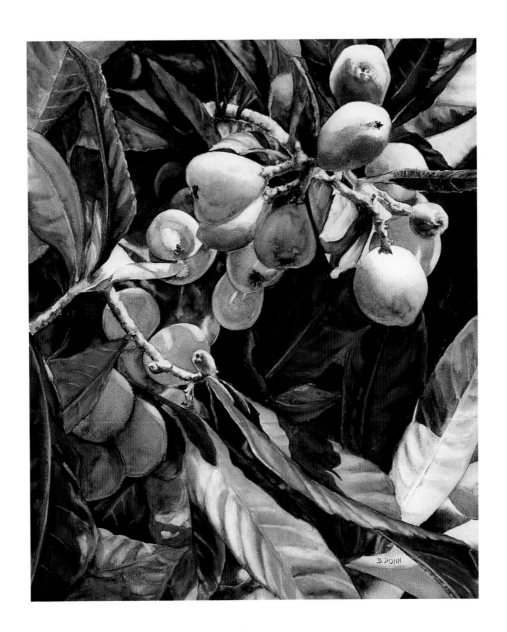

Brian Donn

Loquat Cascade
18" x 15" (46 cm x 38 cm)
Canson-Montval 140 lb. cold press

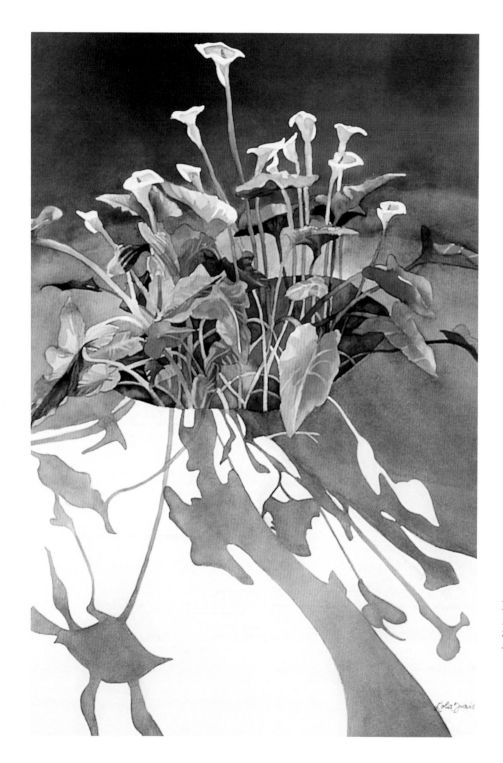

Lola Juris
Lily Legacy
22 1/2" x 18" (57 cm x 48 cm)
Arches 140 lb. cold press
Watercolor with ink

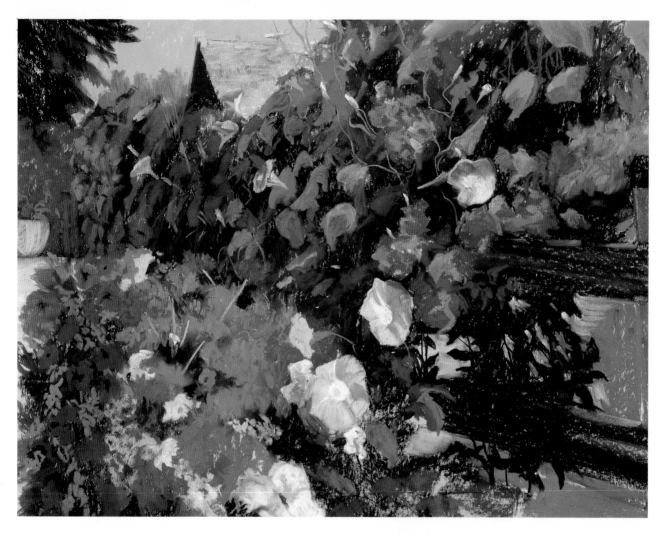

Judith Scott
Magnificent Morning Glories
22" x 28" (55.9 cm x 71.1 cm)
Handmade pastel surface on
100% rag illustration board

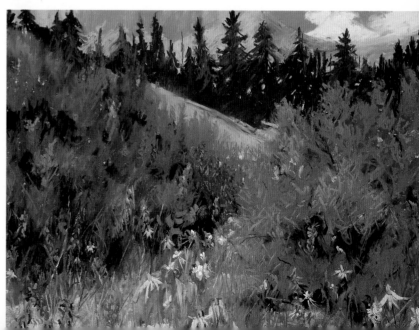

Judith Scott
Rocky Mountain Garden
22" x 28" (55.9 cm x 71.1 cm)
Ersta 7/0 sandpaper

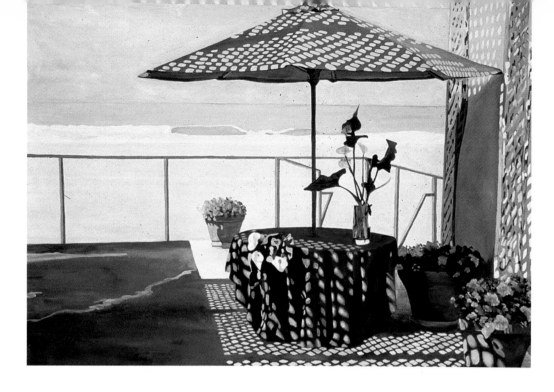

Mark Lee Goldberg
Seymour's Patio
36" x 48" (91 cm x 122 cm)
Canvas

Christine F. Atkins
Apples and Oranges
31" x 22" (79 cm x 56 cm)
Canvas

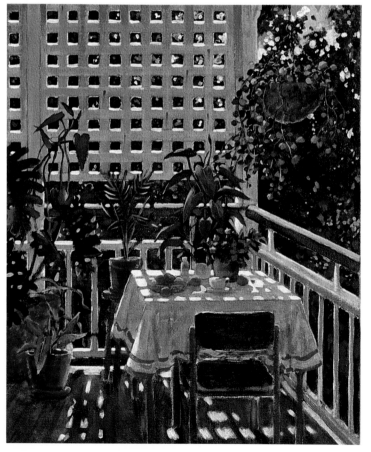

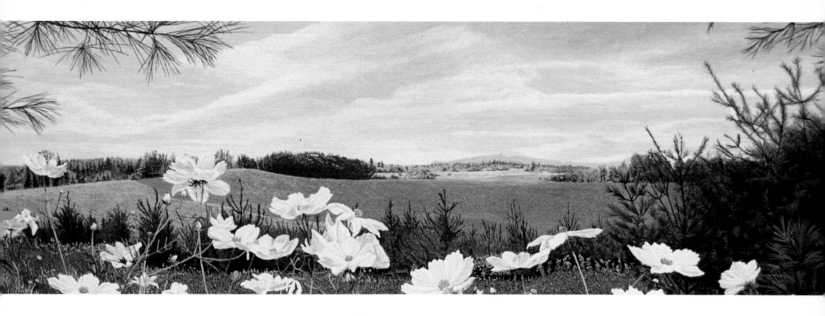

Tim Flanagan
Dance of the Cosmos
10" x 30" (25 cm x 75 cm)
Canvas

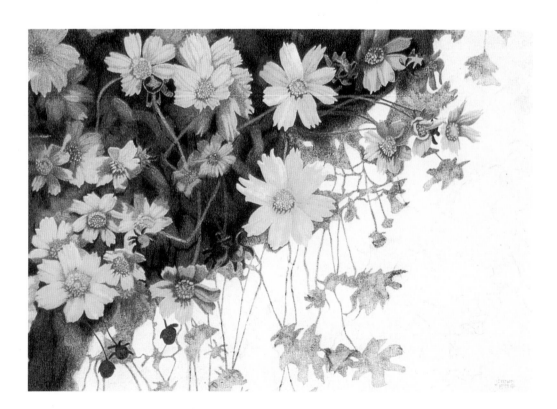

Janet S. Brown
Coreoptical
17" x 23" (43 cm x 58 cm)
Rising museum board

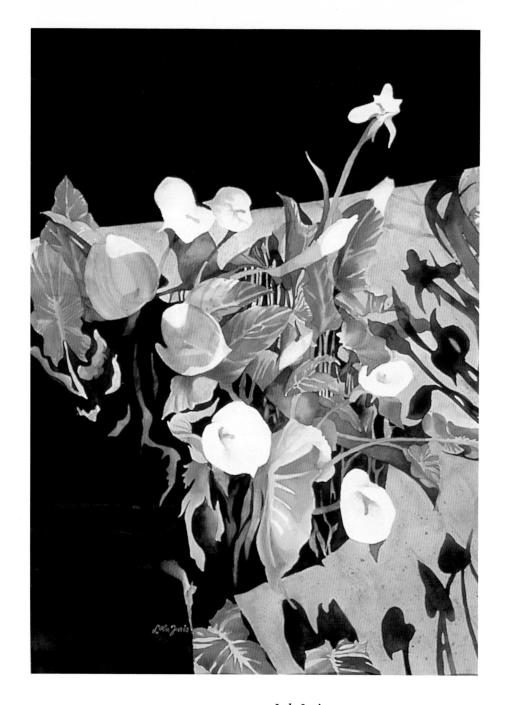

Lola Juris
Languid Lilies
27" x 20" (69 cm x 51 cm)
Arches 140 lb. cold press
Watercolor with colored pencil

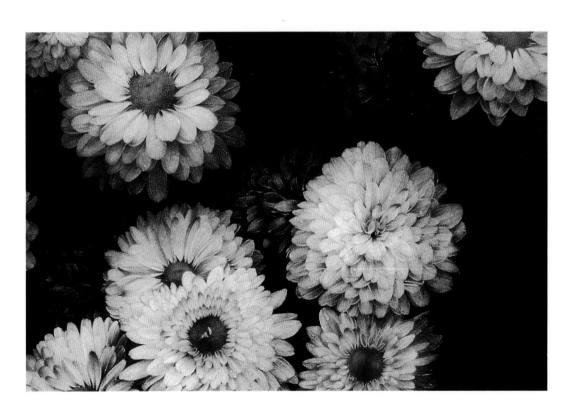

Terry Sciko
The Fourth of October
26" x 36" (66 cm x 91 cm)
Crescent mat board

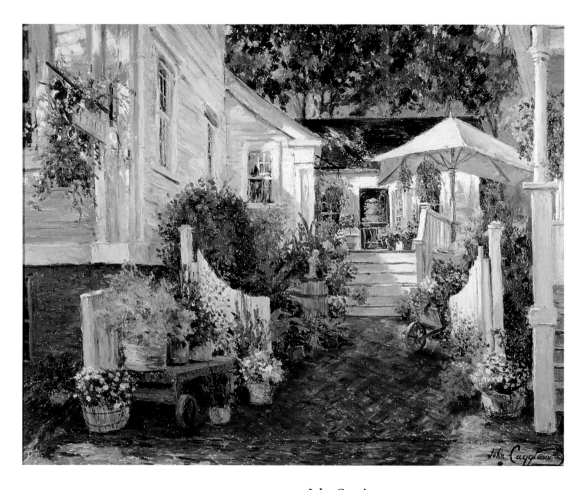

John Caggiano
Un Bella Giordano dei Fiori
24" x 30" (61 cm x 76.2 cm)
Winsor and Newton 260 lb.

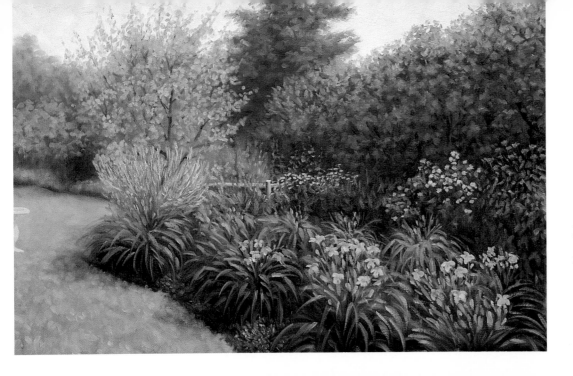

Kathleen Kalinowski
Garden Path
24" x 30" (61 cm x 76.2 cm)
Canvas

Gloria Moses
Garden Series #6
48" x 60" (121.9 cm x 152.4 cm)
Canvas

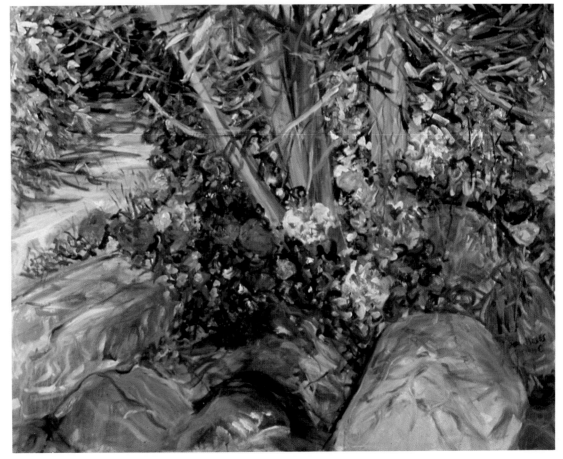

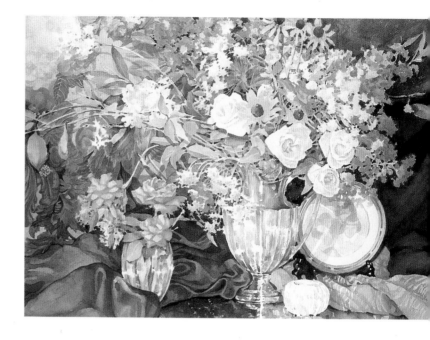

Reneé Faure
Family Portrait
29.5" x 41.5" (74.9 cm x 105.4 cm)
Arches 300 lb.

Joanna Mersereau
Tapestry of Corn
30" x 22" (76.2 cm x 55.9 cm)
Arches 300 lb. cold press

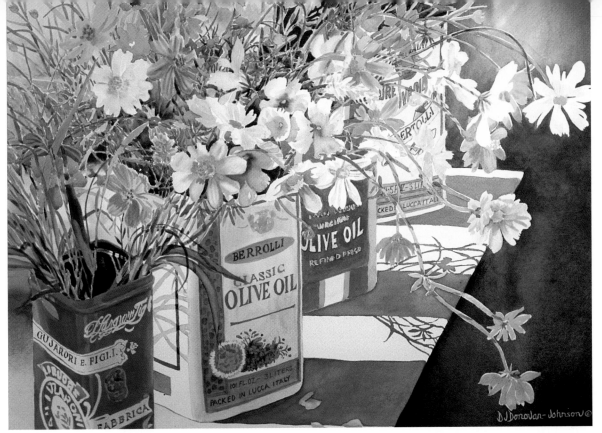

DJ Donovan-Johnson
Farmers Market Cosmos
22" x 30" (56 cm x 76 cm)
Lana Aquarelle 300 lb. cold press paper

Bonnie Brown Fergus
Michigan Memories
32" x 30" (81 cm x 76 cm)
Arches 300 lb. cold press watercolor paper

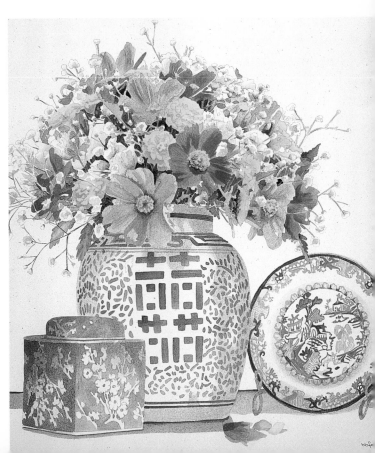

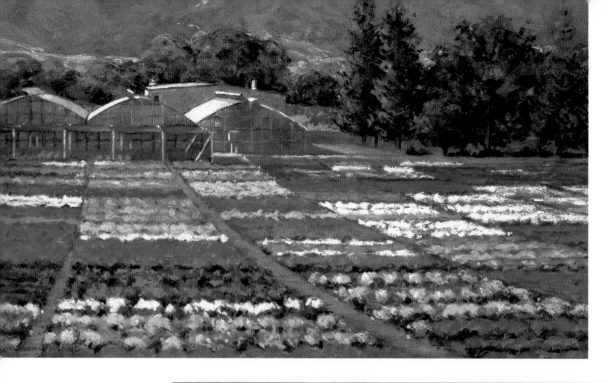

Claire Schroeven Verbiest
Bumper Crop
13" x 22" (33 cm x 55.9 cm)
Pastel with watercolor
Wallis 140 lb. sanded pastel paper

Vicky Clark
Seattle Flower Market
17" x 23" (43.2 cm x 58.4 cm)
*Ebony Minwax-furniture-
stained, 7/0 grit sanded paper*

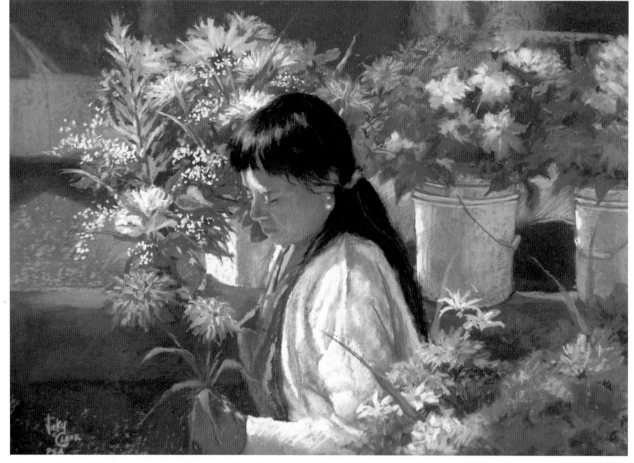

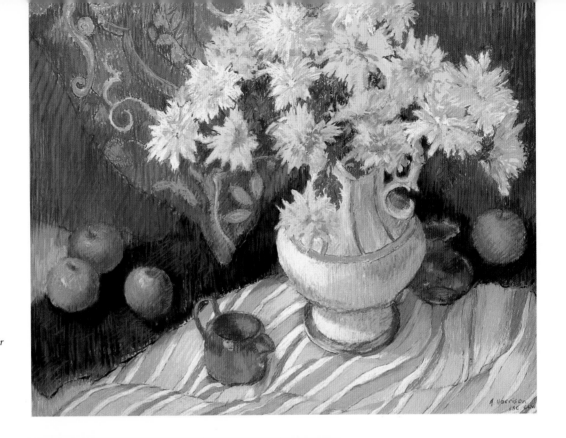

Agnes Harrison
Autumn Glow
21" x 27" (53.3 cm x 68.6 cm)
Pastel with oil and turpentine
Ersta Starcke 7/0 sanded pastel paper

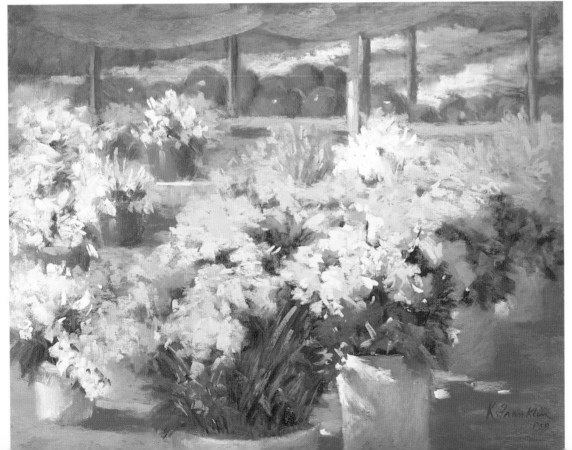

Kaye Franklin
Fall Market
11" x 14" (27.9 cm x 35.6 cm)
Ersta 5/0 grit sanded paper

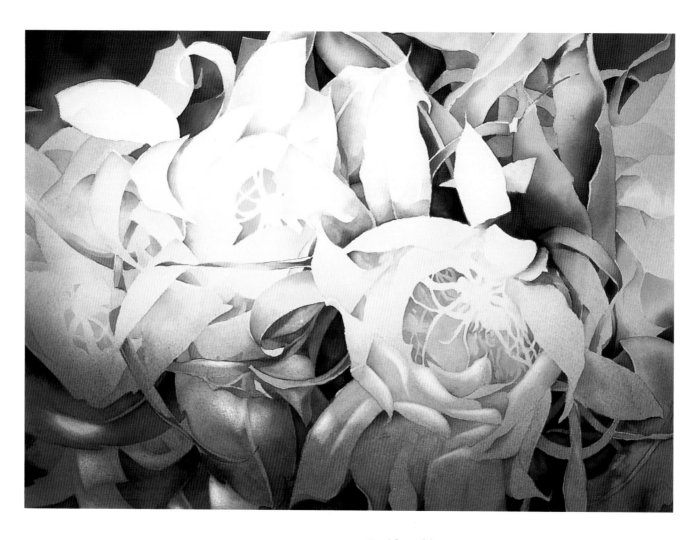

David Maddern
Cereus in Moonlight
22" x 30" (56 cm x 76 cm)
Arches 300 lb. cold press

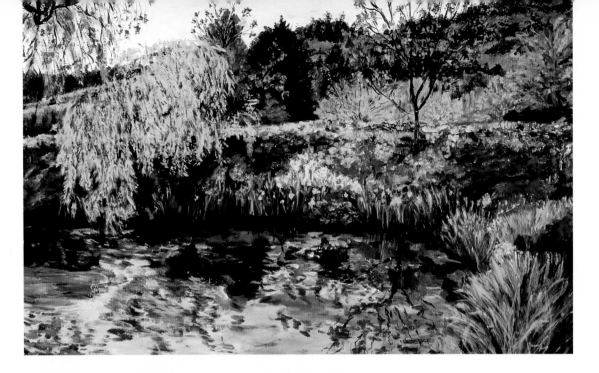

Agnes Manning
Monet's Garden
24" x 36" (61 cm x 91.4 cm)
Canvas

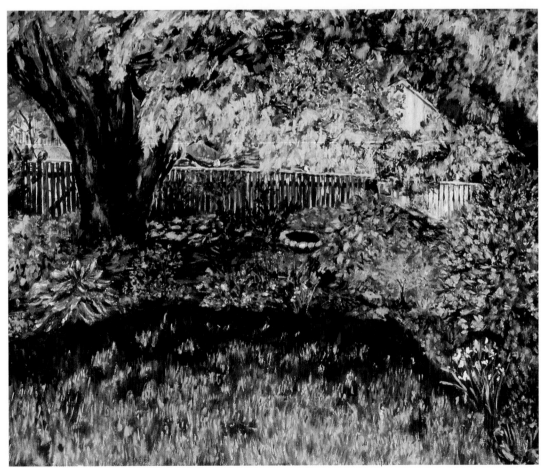

Agnes Manning
Betty's Garden
28" x 28" (71.1 cm x 71.1 cm)
Canvas

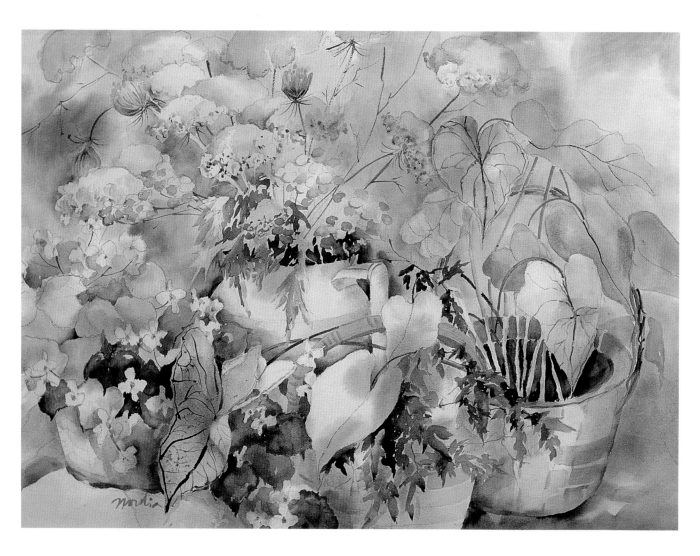

Nordia Kay
Summer's Bounty
22" x 30" (56 cm x 76 cm)
Arches 140 lb. cold press

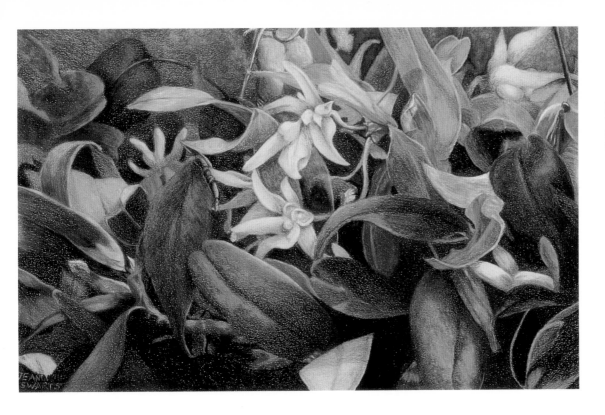

Jeannine Swarts
Tropical Flowers I
14" x 18" (36 cm x 46 cm)
Crescent mat board

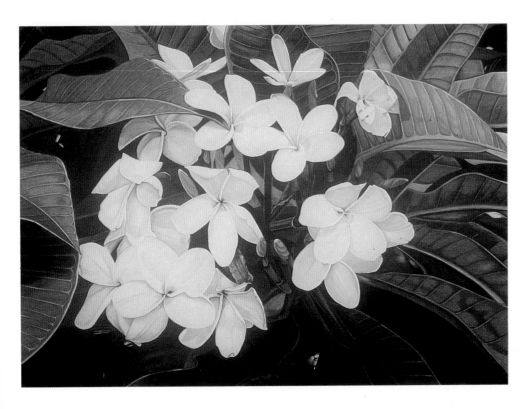

Mary Pohlmann
White Frangipani
22" x 30" (56 cm x 76 cm)
Arches hot press watercolor paper

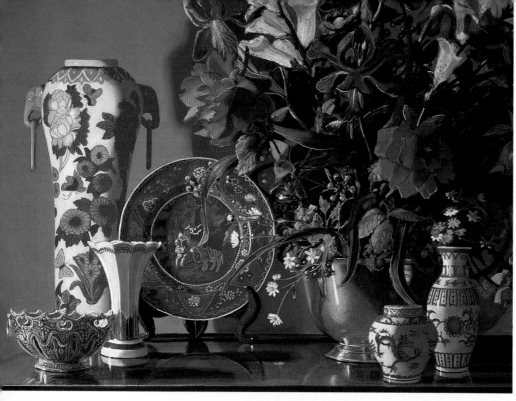

Patty Herscher
Porcelaine
32" x 40" (81.3 cm x 101.6 cm)
Pastel cloth

Patty Herscher
Jardin D'Hiver
32" x 40" (81.3 cm x 101.6 cm)
Pastel cloth

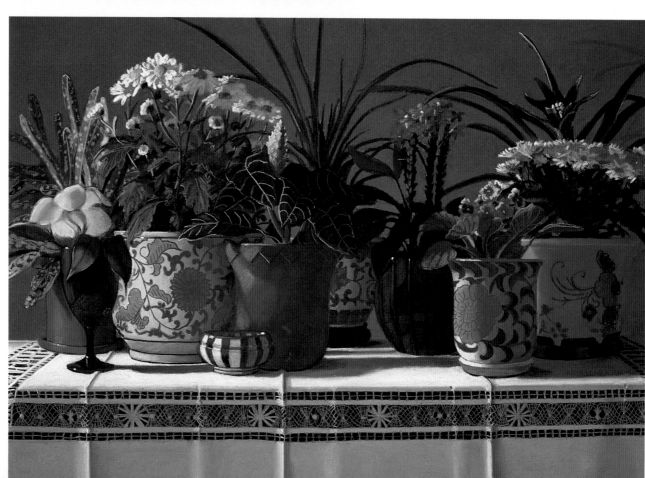

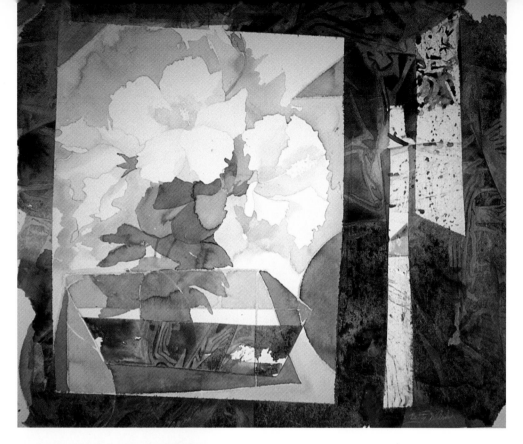

Betty Welch
The Arrangement
22.5" x 25.5" (57 cm x 65 cm)
Crescent #110 illustration board

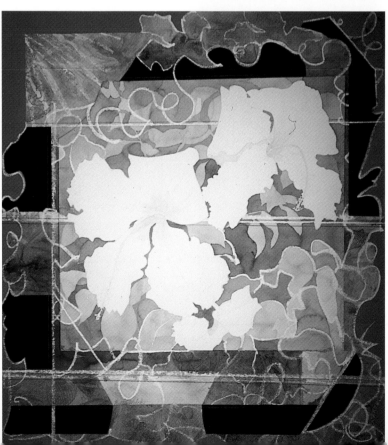

Betty Welch
Hibiscus Series
30" x 27" (76 cm x 69 cm)
Crescent #110 illustration board

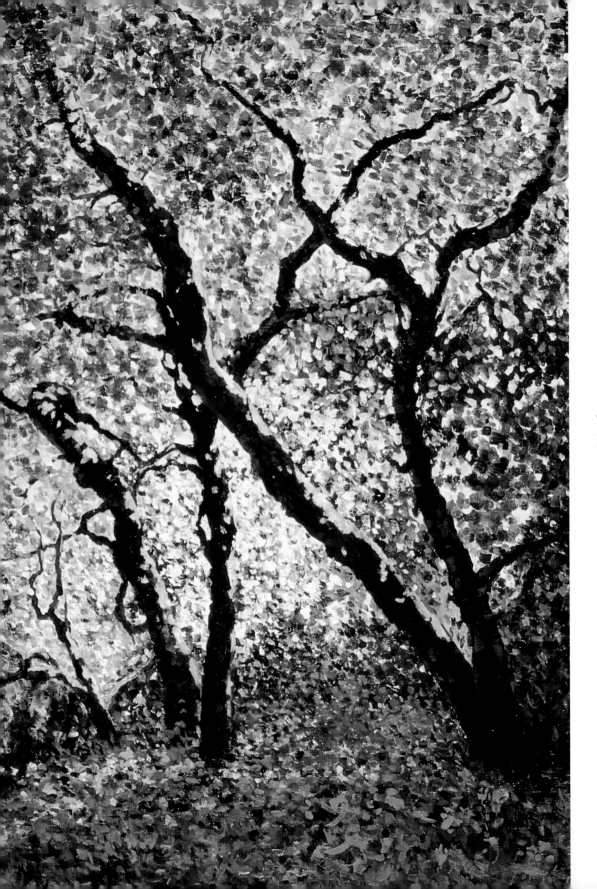

Gerri Brutschy
Nature's Mosaic
36" x 24" (91.4 cm x 61 cm)
Stretched linen canvas

Ann Pember
Magnolia
14" x 21" (35.6 cm x 53.3 cm)
Arches 140 lb. cold press

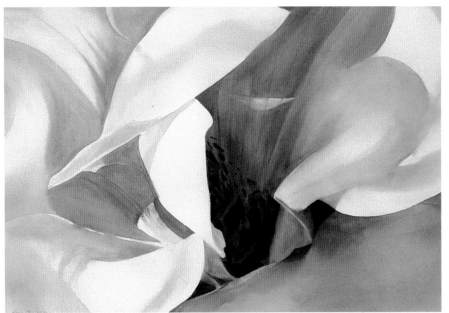

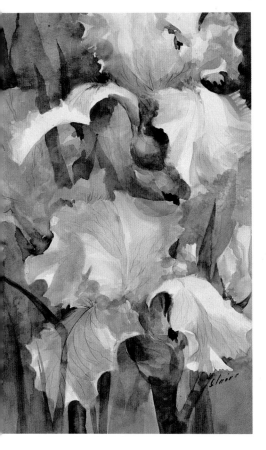

Elaine Frederickson
White Irises
22" x 30" (55.9 cm x 76.2 cm)
Whatman 140 lb. cold press

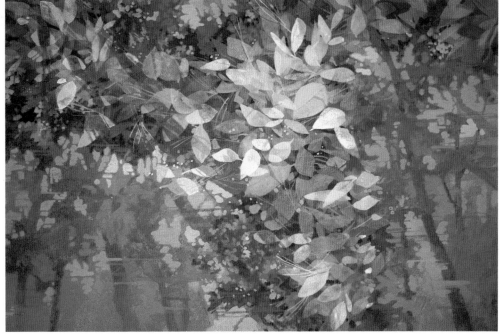

Cynthia L. Wilson
Windswept
15" x 22" (38.1 cm x 55.6 cm)
Arches 140 lb. cold press
Media: 100% acrylic layered washes

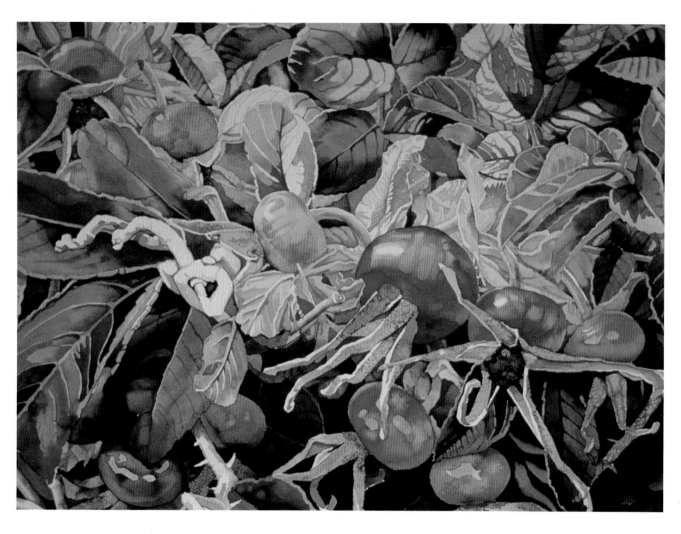

Mary Sorrows Hughes
Coastal Rose Hips — Maine Surprise
22" x 30" (56 cm x 76 cm)
Arches 300 lb. cold press

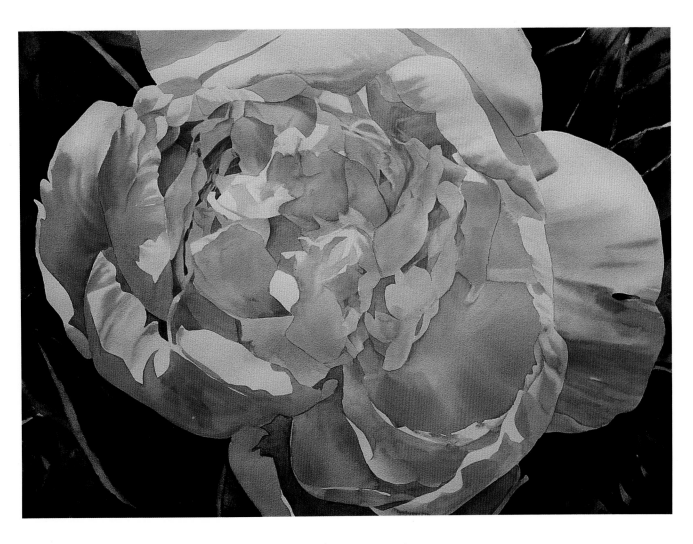

Ann Pember
Peony Unfurled
21" x 29" (53 cm x 74 cm)
Saunders Waterford 140 lb. cold press

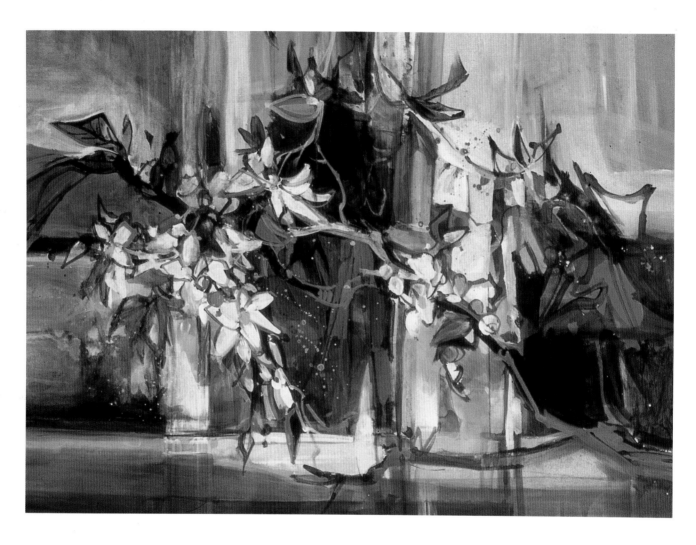

Jane R. Hofstetter
Emergence
21" x 29" (53 cm x 74 cm)
Strathmore 5-ply illustration board
Watercolor with acrylic

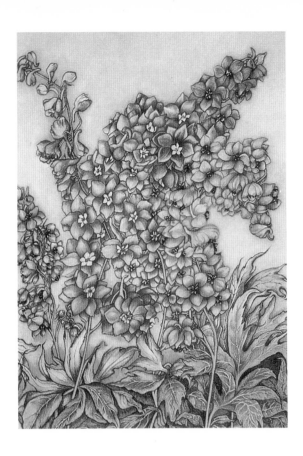

Martha Cardot-Greiner
Purple Delphiniums-After the Storm
17" x 28" (43 cm x 71 cm)
Strathmore bristol board

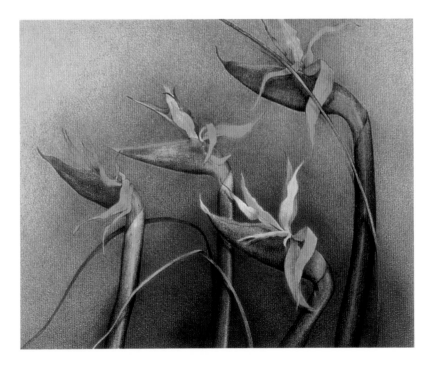

Kathryn Conwell
Strelitizia Reginae
21" x 24" (53 cm x 61 cm)
Museum board

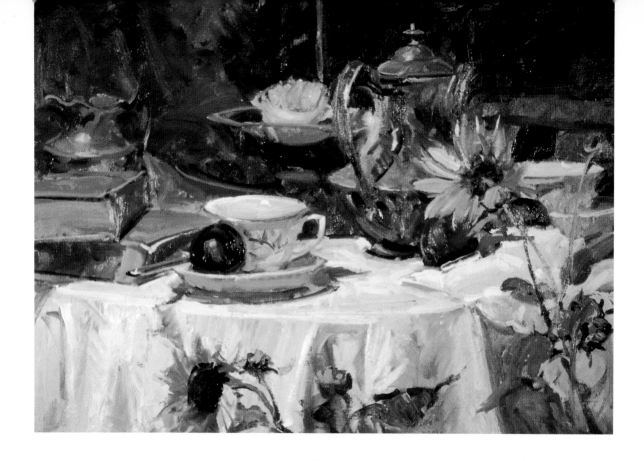

Suzanne Shedosky
Plums
18" x 24" (45.7 cm x 61 cm)
Masonite panel

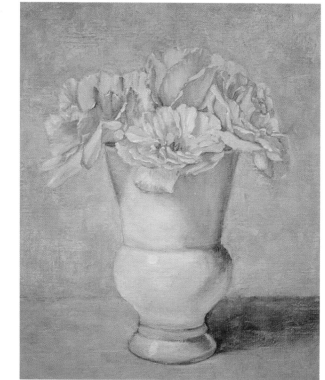

Elsie Eastman
Pale Roses
12" x 10" (30.5 cm x 25.4 cm)
Lead-primed linen

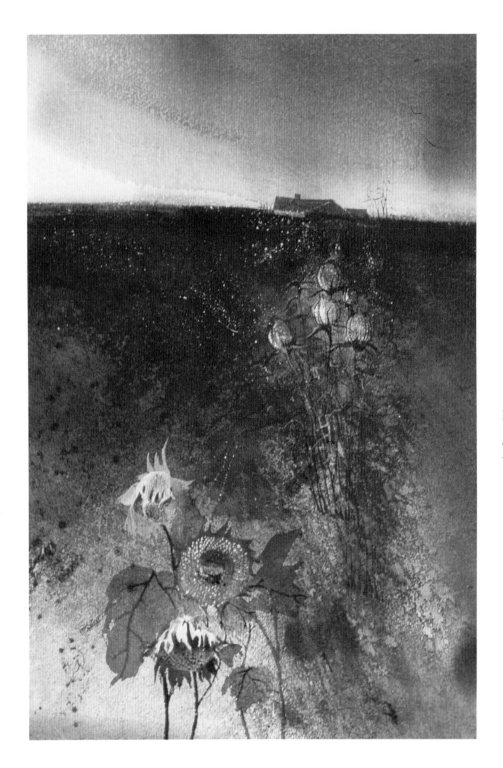

Benjamin Mau
Wind Dusk
40" x 30" (102 cm x 76 cm)
Arches 140 lb. cold press

Mickey Daniels
Moonlight Serenade
14" x 20" (35.6 cm x 53.3 cm)
Arches 140 lb. cold press

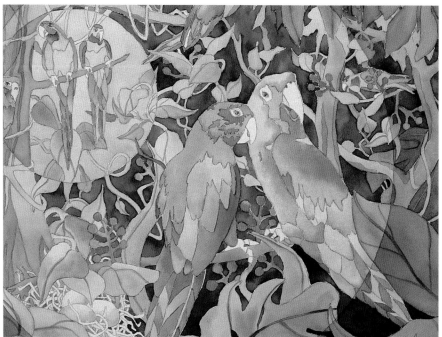

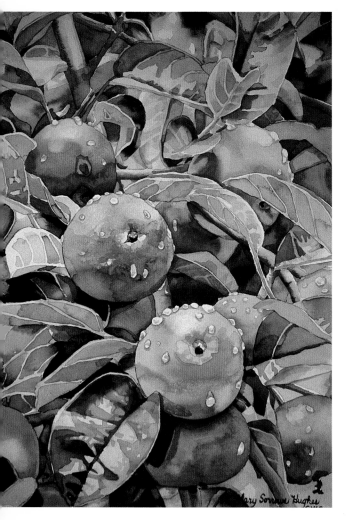

Mary Sorrows Hughes
Strawberry Banke Appeal
15" x 21" (38.1 cm x 53.3 cm)
Arches 140 lb. cold press

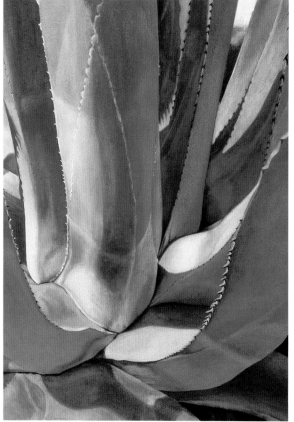

Nedra Tornay, N.W.S.
Agave Cactus
30" x 22" (76.2 cm x 55.9 cm)
Waterford 300 lb. rough

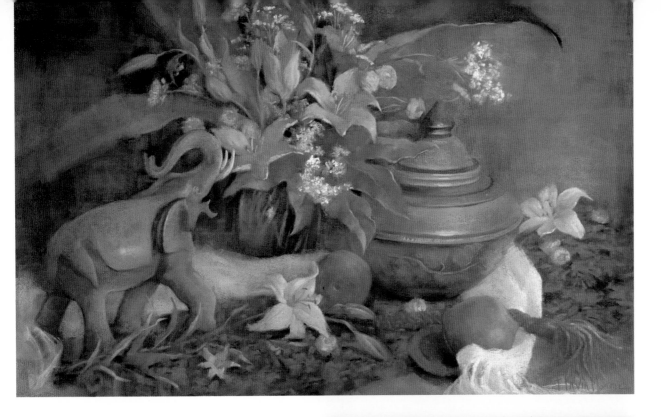

Flavia Monroe
Orange Lillies
24" x 36" (61 cm x 91.4 cm)
Pastel cloth

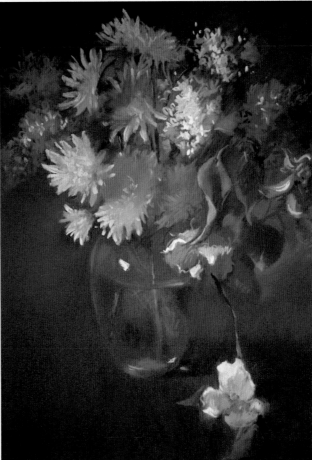

Christina Debarry
Mixed Bouquet
19" x 13" (48.3 cm x 33 cm)
Sanded pastel paper

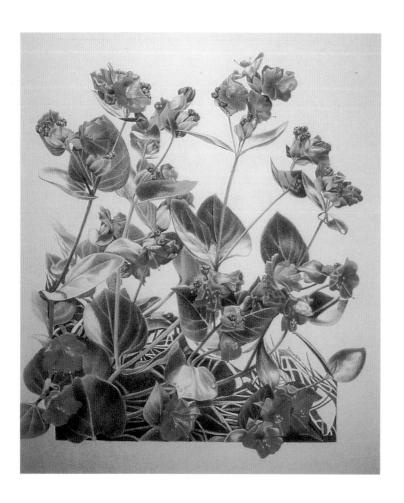

Rebecca Brown-Thompson
Mirabilis Macfarlane
20" x 18" (51 cm x 46 cm)
Scanner board

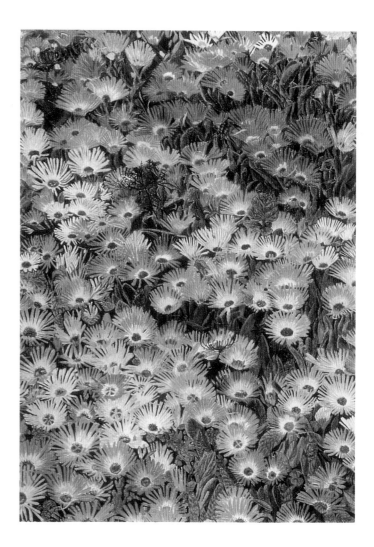

Mary G. Hobbs
Oregon August
32" x 24" (81 cm x 61 cm)
Onionskin silk paper

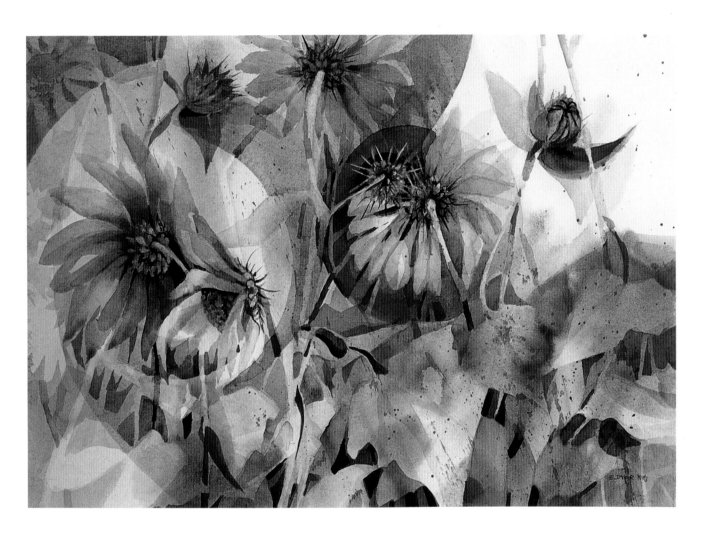

Evalyn J. Dyer
Sunflower Symphony
22" x 30" (56 cm x 76 cm)
Whatman 200 lb. cold press

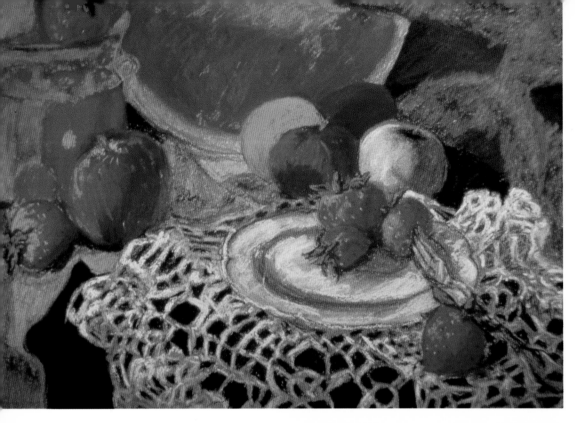

Mary Jane Manford
Seedless Watermelon
15" x 21" (38.1 cm x 53.3 cm)
Canson Mi-Teintes paper

Agnes Harrison
Poppies
20" x 26" (50.8 cm x 66 cm)
Pastel with oil and turpentine
Ersta Starcke 7/0 sanded pastel paper

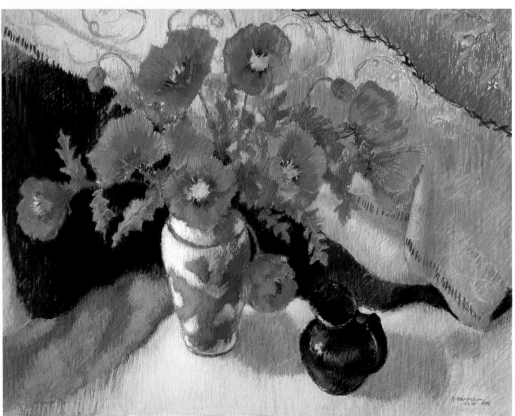

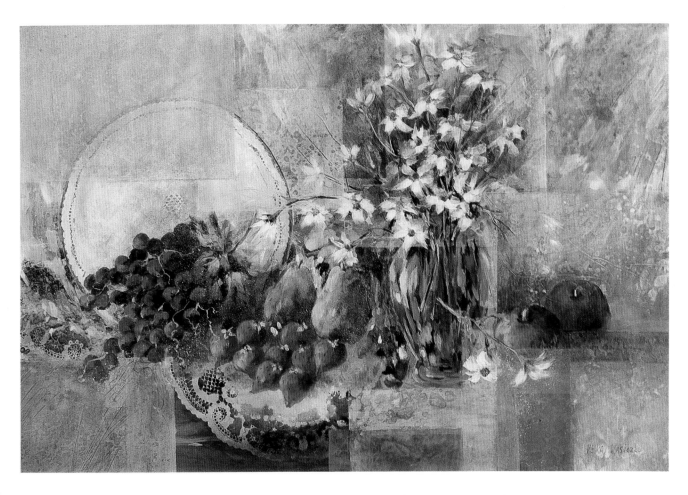

Wolodimira Vera Wasiczko
A Still Moment III
20" x 30" (51 cm x 76 cm)
Crescent 100% rag hot press
Watercolor with acrylic

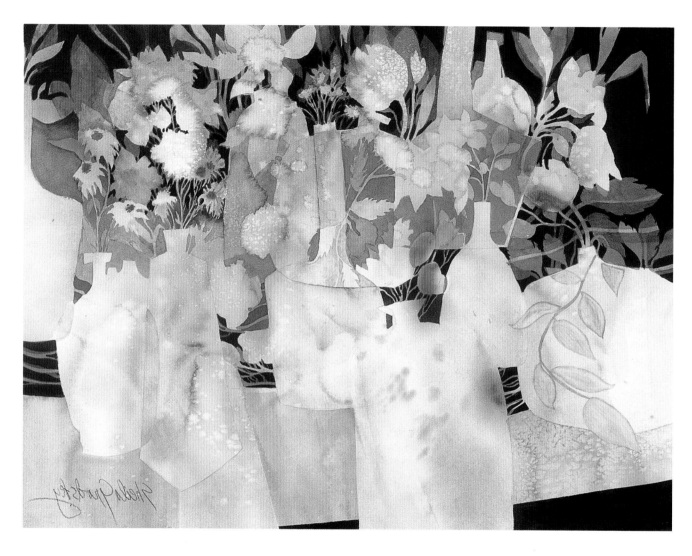

Sheila T. Grodsky
Bottlescape
22" x 30" (56 cm x 76 cm)
Lanaquarelle 140 lb. hot press

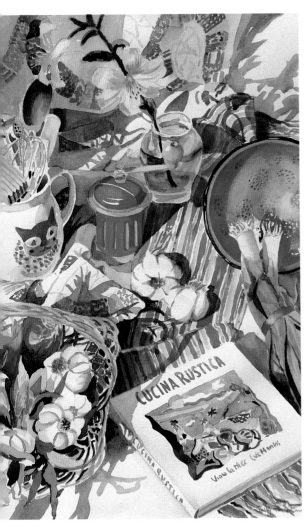

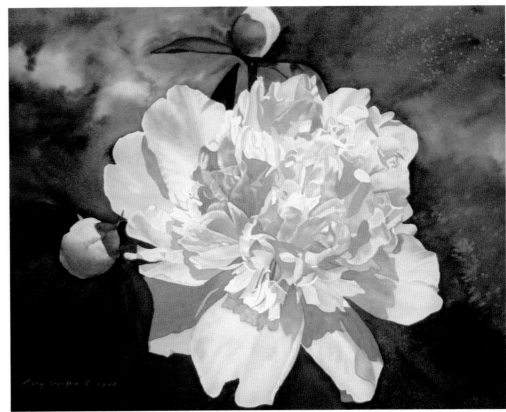

Mary Griffin, N.E.W.S.
Pink and White Peony
30" x 22" (76.2 cm x 55.9 cm)
Arches 300 lb. cold press

Sally Bookman
Cucina Rustica
18" x 24" (45.7 cm x 60.9 cm)
Arches 140 lb. cold press

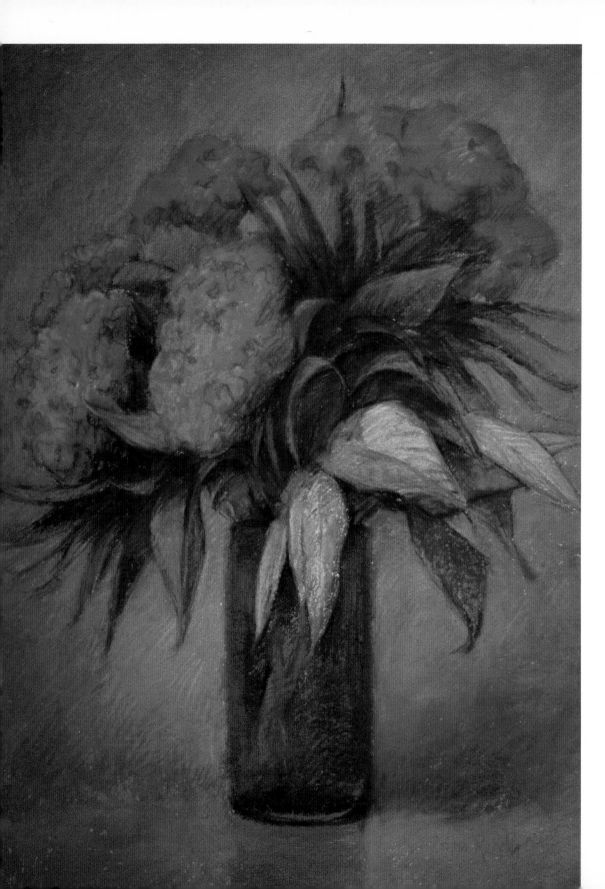

Mitsuno Ishii Reedy
Cocks Comb
29" x 22" (73.7 cm x 55.9 cm)
Pastel with watercolor
400 lb. Watercolor paper

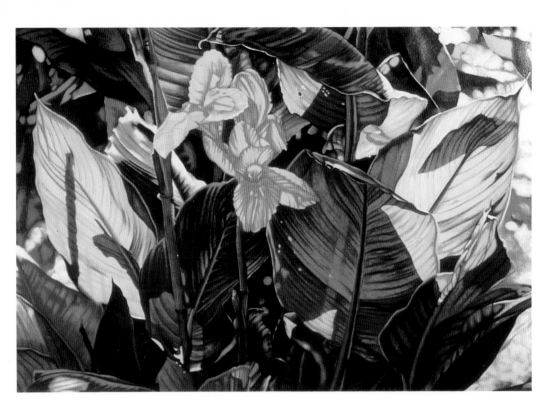

Tim O'Neal
Rand Cannas 2
21" x 30" (53 cm x 76 cm)
White Stonehenge

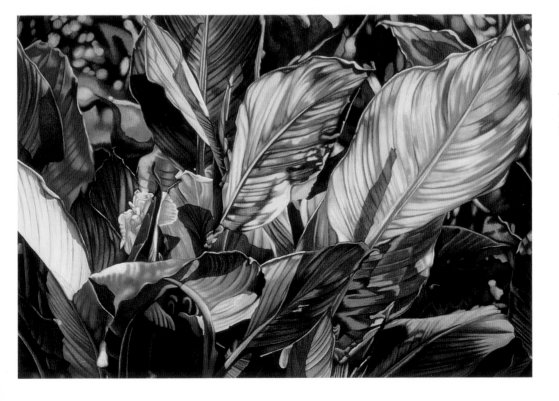

Tim O'Neal
Rand Canna 1
21" x 30" (53 cm x 76 cm)
White Stonehenge

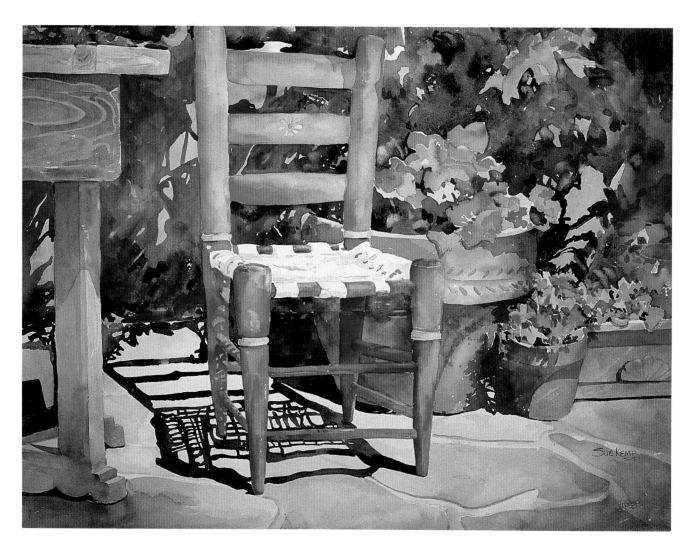

Sue Kemp
The Red Chair
22" x 30" (56 cm x 76 cm)
Arches 300 lb. cold press

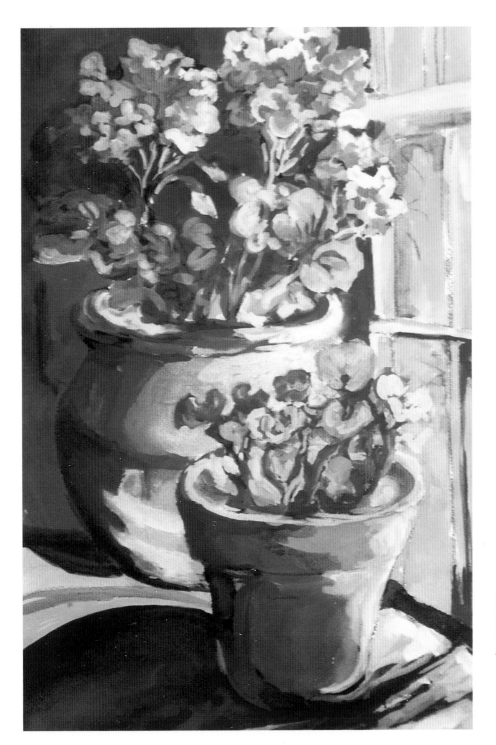

Lois Showalter
By the Window
21" x 14" (53 cm x 36 cm)
*RWatercolor with acrylic,
gouache, nu-pastels, and ink*

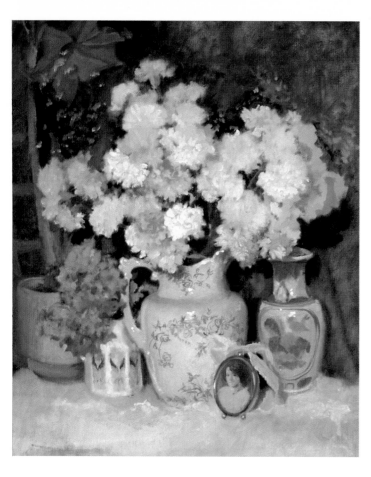

Roberta Carter Clark
Pink Carnations
32" x 27" (81.2 cm x 68.6 cm)
Linen canvas

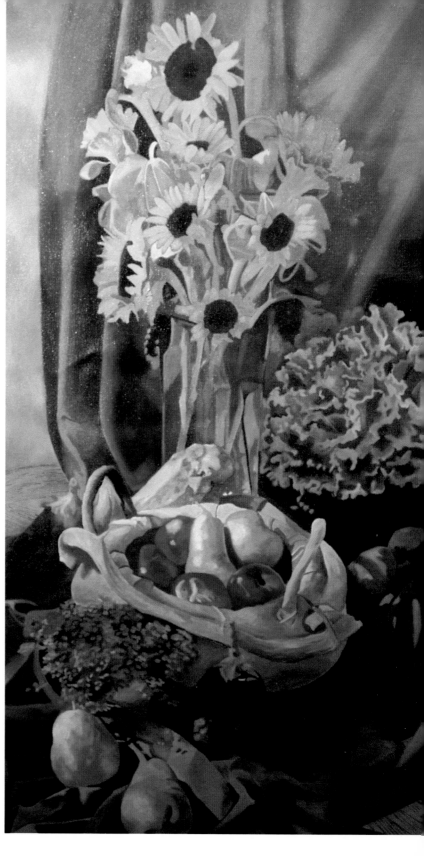

Kathryn S. Heuzey
Kitchen Landscape Sunflowers
36" x 23" (91.4 cm x 58.4 cm)
Canvas

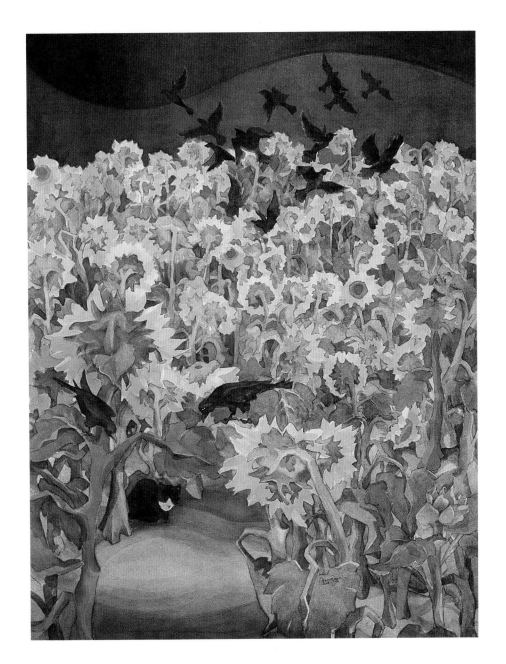

Janet B. Walsh, A.W.S.
If You Snooze—You Lose
30" x 40" (76 cm x 102 cm)
Lanaquarelle 555 lb. cold press
Watercolor with aquacryl

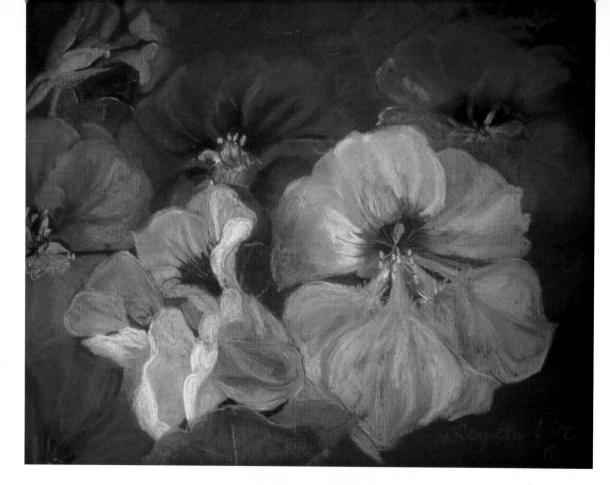

Sibylla Voll
Capucchins
15.5" x 18.5" (39.4 cm x 47 cm)
Pastel with vine charcoal
Ersta pastel sandpaper

Donna Stallard
What Used to Be
30" x 44" (76.2 cm x 111.8 cm)
Rives BFK heavyweight gray paper

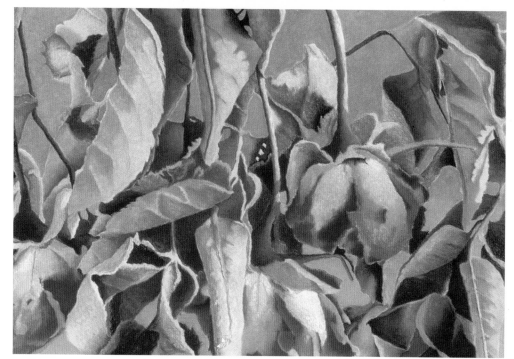

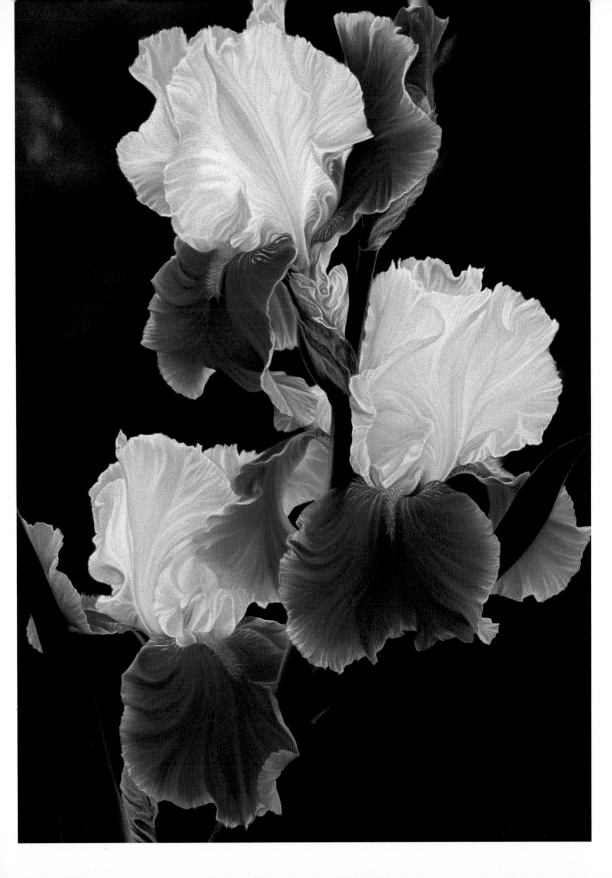

Miciol Black
Flirtation
28" x 20" (71.1 cm x 50.8 cm)
Canson Mi-Teintes 108 lb. paper

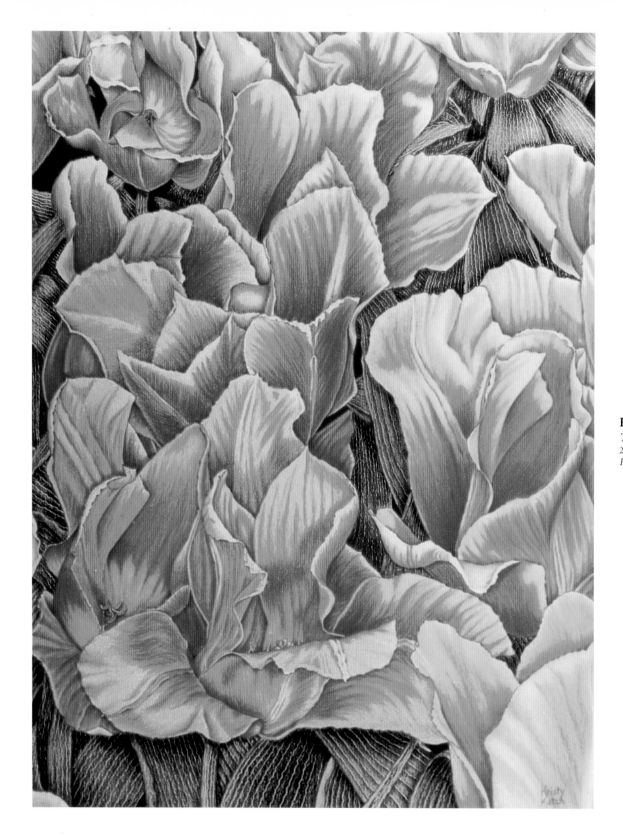

Kristy A. Kutch
Tulip Riot
26" x 20" (66 cm x 51 cm)
Rising museum board

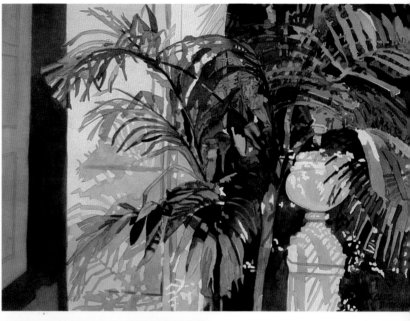

Georgia A. Newton
Patterns of Aquilegia
22" x 30" (55.9 cm x 76.2 cm)
Arches 140 lb. hot press

Cecie Borschow
Dominican Courtyard
22" x 33" (55.9 cm x 83.8 cm)
Arches 140 lb.

Margaret Scanlan, A.W.S., W.H.S.
Meadow II
30" x 40" (76.2 cm x 101.6 cm)
Strathmore 500 Series heavy weight

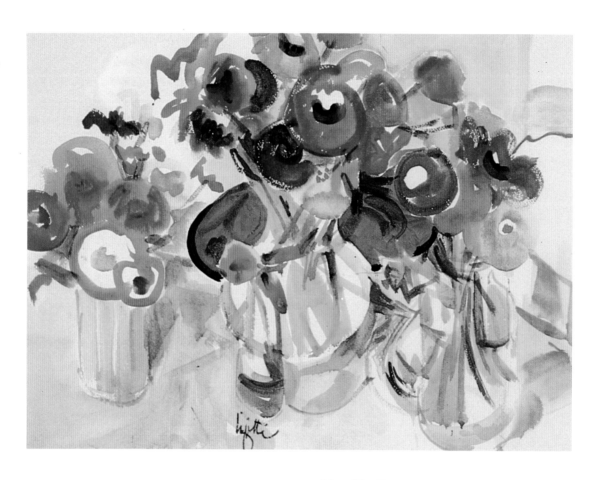

Mary Lizotte
Lollipops
14" x 18.5" (35.6cm x 47.0cm)
Arches 140 lb. cold press

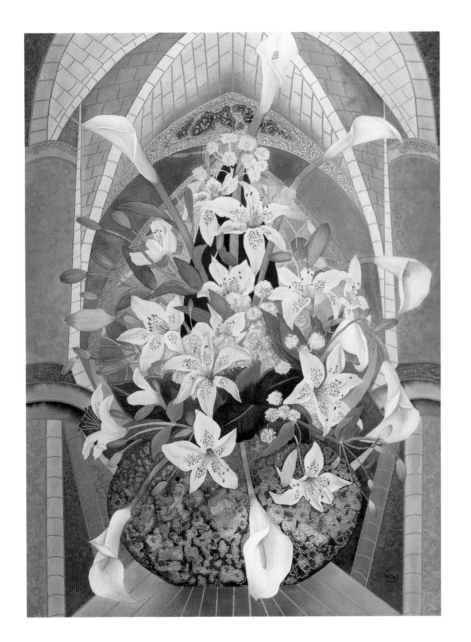

Kathryn S. Heuzey
Hydrangeas and Figs
22" x 27" (56 cm x 69 cm)

Zetta Jones
Cuenca
29" x 41" (73.7cm x 104.1cm)
Arches 555 lb. cold press
Mixed media: Transparent watercolor,
gold and silver ink embellishment

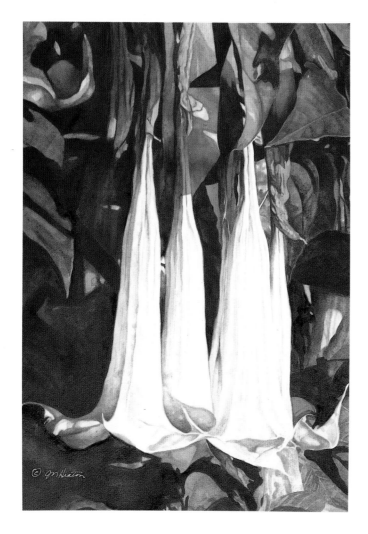

Janet Heaton
Datura
29.5" x 22.5" (74.9cm x 57.2cm)
Arches 300 lb. rough

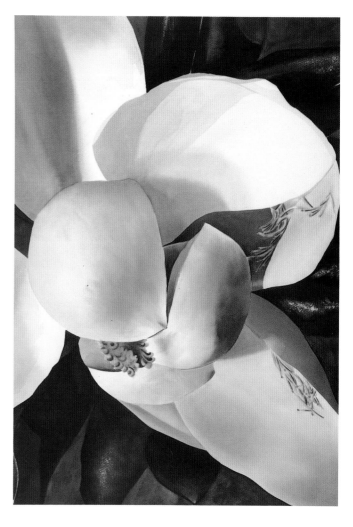

Stephanie J. Brichetto
Southern Belle II
28.5" x 20.5" (72.4cm x 52.1cm)
140 lb. Cold press

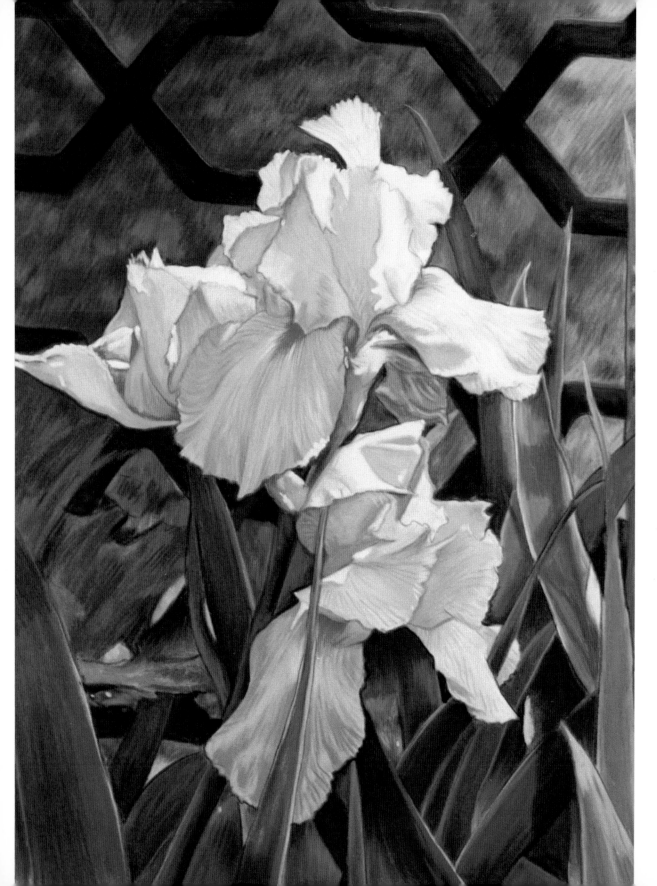

Kathy Shumway-Tunney
Along Prince Street
24" x 18" (61 cm x 45.7 cm)
65 lb. Velour pastel paper

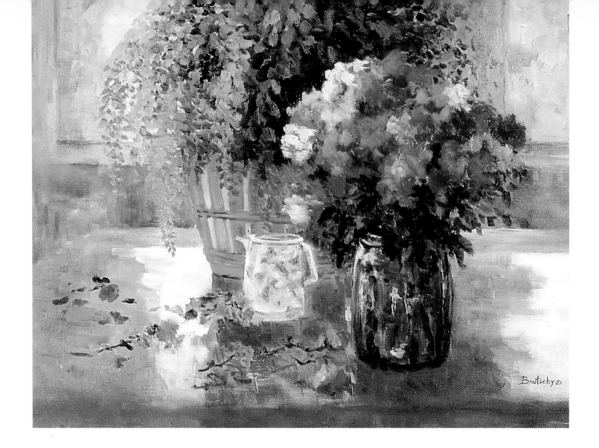

Gerri Brutschy
Still Life with Fern
20" x 24" (50.8 cm x 61 cm)
Stretched canvas

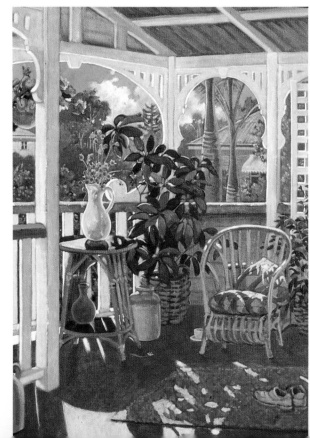

Christine F. Atkins
Tropical Verandah
31" x 22" (78.7 cm x 55.9 cm)
Canvas

Linda L. Spies
Scarlet Flame
19.75" x 26.25" (50.2cm x 66.7cm)
Arches 140 lb. cold press

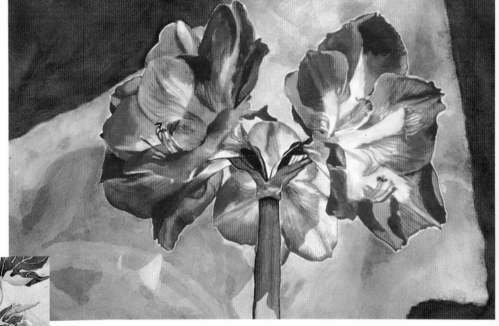

Nini Bodenheimer
Gerbers, Fatsia, and Iris
20" x 32" (50.8cm x 81.3cm)
Arches 140 lb. hot press

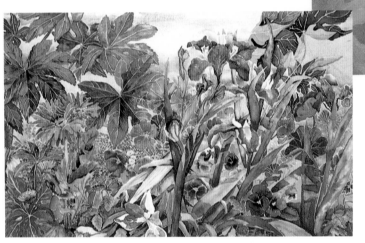

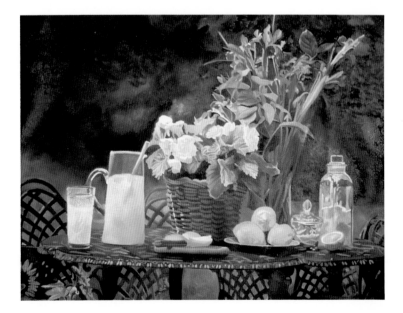

Kathryn S. Heuzey
Lemonade
27" x 22" (69 cm x 56 cm)

Connie Kuhnle
Conversations
15" x 22" (38.1 cm x 61 cm)
Canson Mi-Teintes paper

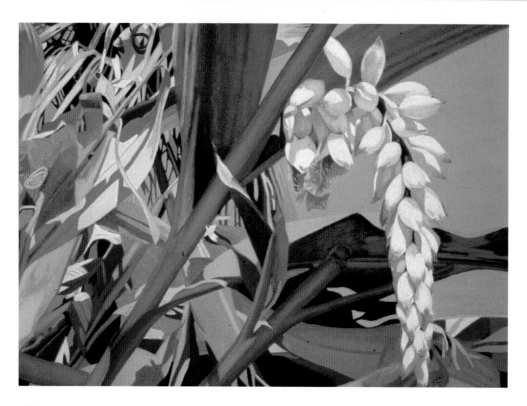

Toni Lindahl
Bahama Floral
23" x 32" (58.4 cm x 81.3 cm)
Arches 140 lb. watercolor paper

66

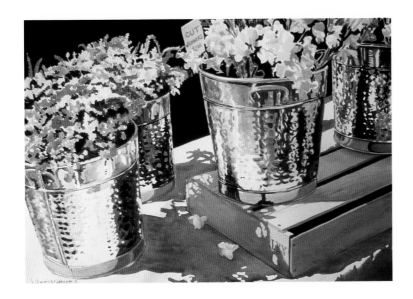

DJ Donovan-Johnson
Farmers Market Reflections VI
22" x 30" (56 cm x 76 cm)
Acrylic and watercolor

Mary G. Hobbs
Before the Stars Turn To Ebony
30" x 32" (76 cm x 81 cm)
Rising museum board 1607

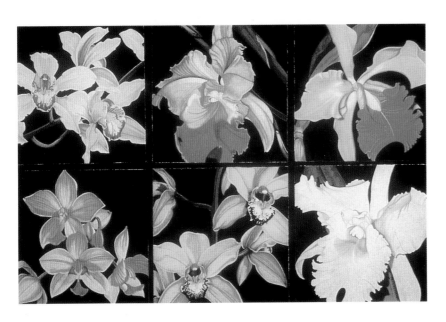

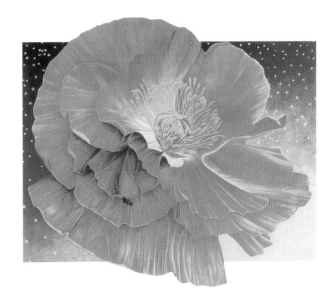

Mary Pohlmann
Orchids II
20" x 30" (51 cm x 76 cm)
Arches hot press watercolor paper

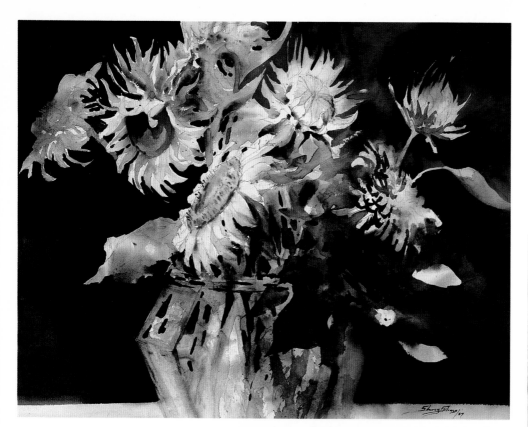

Sherry Silvers
Show Girls
28" x 20" (71.1 cm x 50.8 cm)
Arches 140 lb.
Media: Rice paper, string, pastels

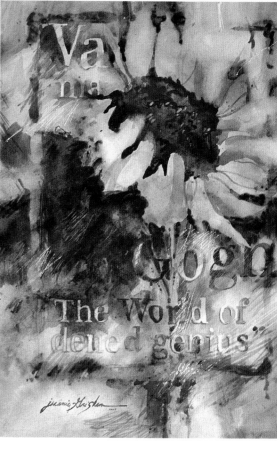

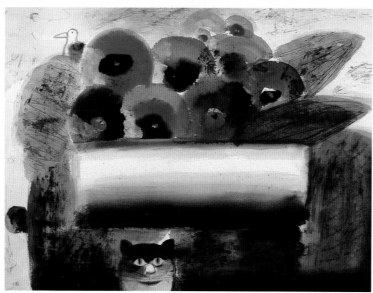

Gregory Litinsky, N.W.S.
Cat and Bird
22" x 30" (55.9 cm x 76.2 cm)
Arches 140 lb. cold press

Jeannie Grisham
Van Gogh's Inspiration
21" x 14" (53.3 cm x 35.6 cm)
Lana Aquarelle 140 lb. hot press

Joyce Gow, M.W.S.
Petals
21" x 29" (53.3 cm x 73.7 cm)
Arches 140 lb. cold press

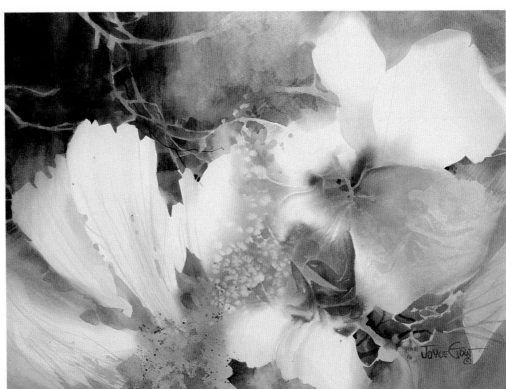

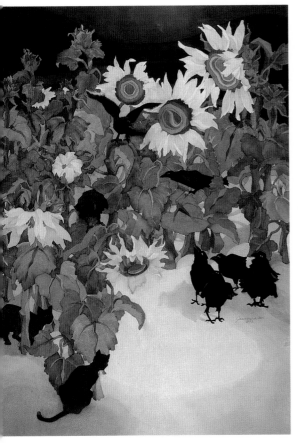

Janet B. Walsh, A.W.S.
Waiting Game
30" x 40" (76.2 cm x 101.6 cm)
300 lb. cold press

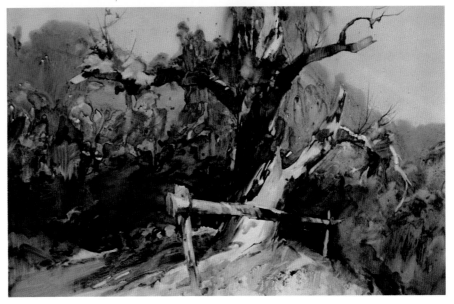

Ruth Wynn
Nesting Place
21" x 28" (53.3 cm x 71.1 cm)
Strathmore high surface

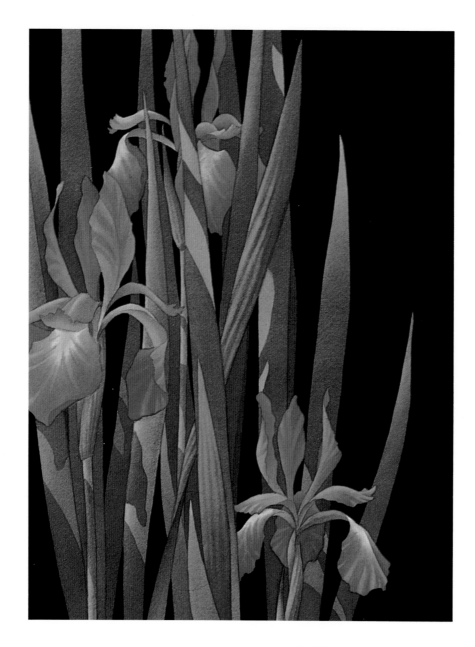

Ann Salisbury
Blue Flag Iris
11" x 22" (27.9cm x 55.9cm)
Arches 140 lb. cold press
Mixed media: Acrylic, gouache

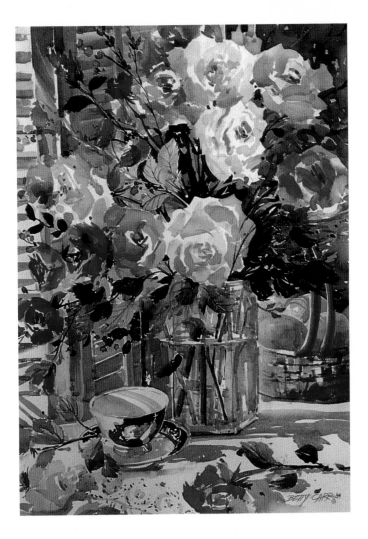

Betty Carr
Summer Cut
17" x 23" (43.2cm x 58.4cm)
140 lb. Cold press

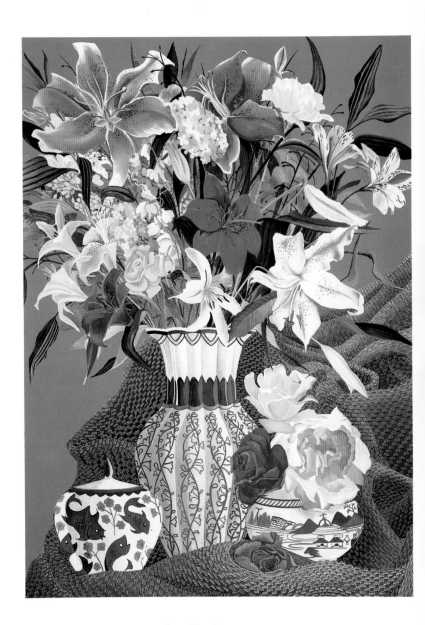

Patricia Hough Pollard
A Tribute to Flowers
21.25" x 28.8" (54.0cm x 73.3cm)
200 lb. Cold press
Mixed media: Gouache

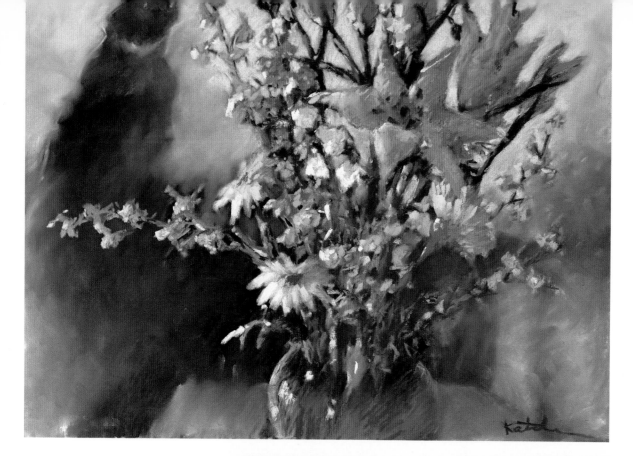

Carole Katchen
Silent Witness
19" x 25" (48.3 cm x 63.5 cm)
Sennelier La Carte pastel paper

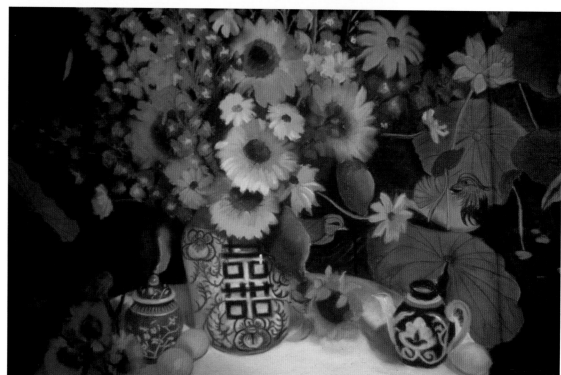

Patricia Suggs
Oriental Arrangement
24" x 36" (61 cm x 91.4 cm)
*Canadian Sabretooth handmade
acid-free bristol*

Hilda Stuhl
Rose & Ribbons
22" x 30" (55.9 cm x 76.2 cm)
Arches 140 lb. cold press

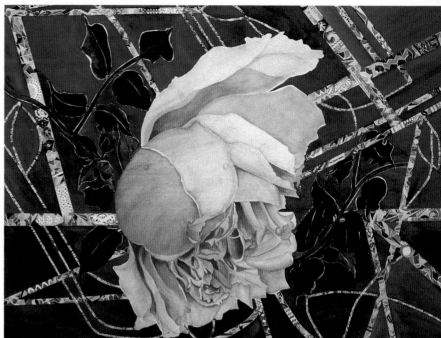

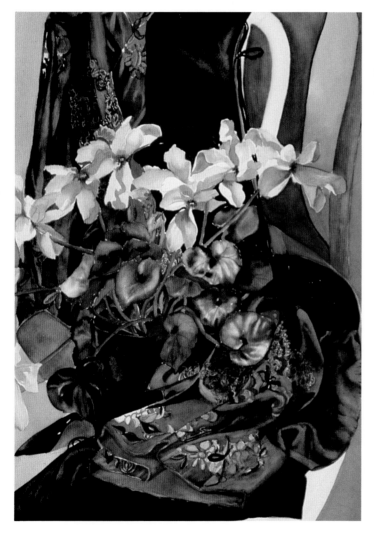

Pat Berger
Bromeliad Medley
36" x 22" (91.4 cm x 55.9 cm)
Arches 500 lb. hot press

Carolyn H. Pedersen, N.W.S.
Oriental Treasure
22" x 30" (55.9 cm x 76.2 cm)
Arches 300 lb. cold press

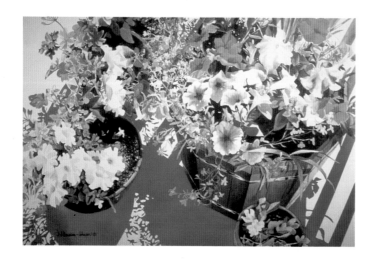

DJ Donovan-Johnson
Patio Series VIII
22" x 30" (56 cm x 76 cm)
Watermedia

Charlotte L. Cornette
Floral Design
25" x 25" (63.5cm x 63.5cm)
Lang 300 lb.
Mixed media: Acrylic

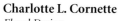

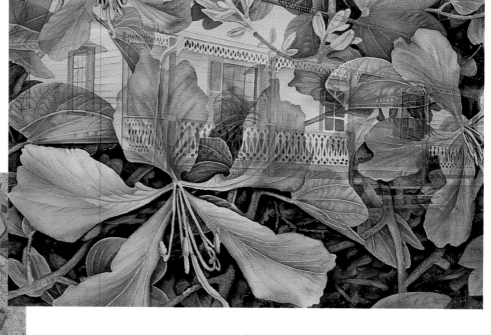

C. Patricia Scott
Double Exposure VI: Orchid Tree House
22" x 30" (55.9cm x 76.2cm)
Arches 140 lb. cold press

Martha Kellar
Peach Branch with Vase
30" x 24" (76.2 cm x 61 cm)
Canvas

Linda M. Miller
At Second Glance
26" x 21" (66 cm x 53 cm)
Bristol board, smooth

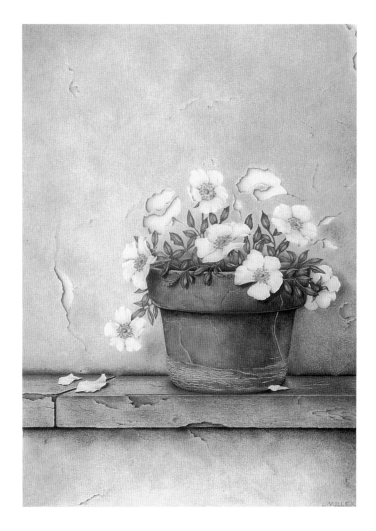

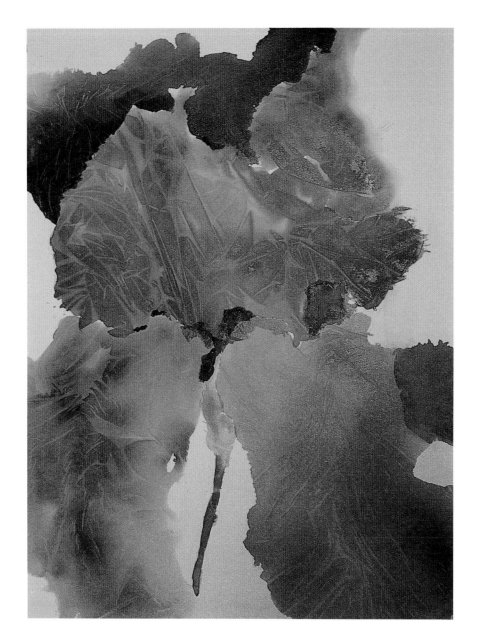

Diane O'Brien
Last June
20" x 30" (50.8cm x 76.2cm)
Strathmore watercolor board

Makie Hino
Red Sunflowers
24.5" x 18" (61.9 cm x 44.9 cm)
Canson pastel paper

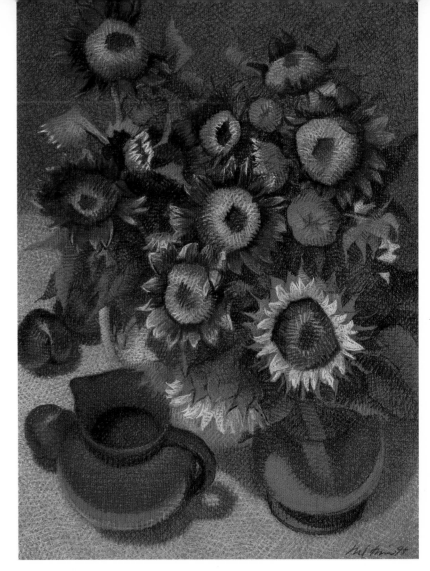

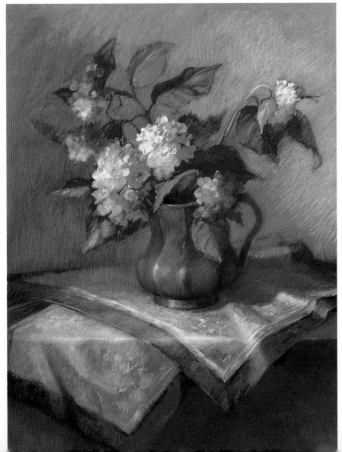

Christina Debarry
Hydrangea with Silk Scarf
24" x 18" (61 cm x 45.7 cm)
Sennelier La Carte sienna pastel paper

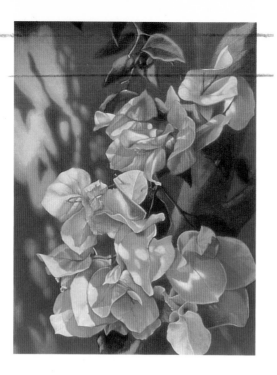

Laura Ospanik
Shades of Bougainvillea
34" x 28" (86 cm x 71 cm)
Canson Mi-Tientes

Susan L. Brooks
Calla Lilies
23" x 27" (58 cm x 69 cm)
Rising museum board

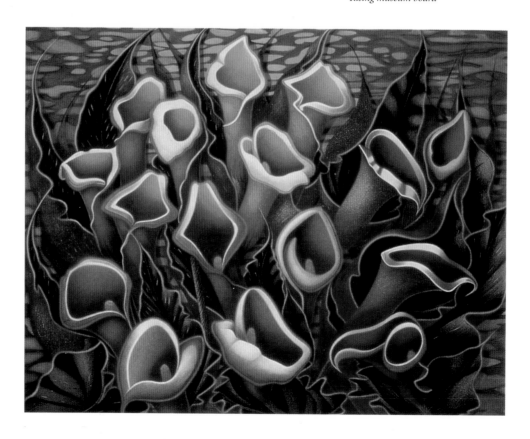

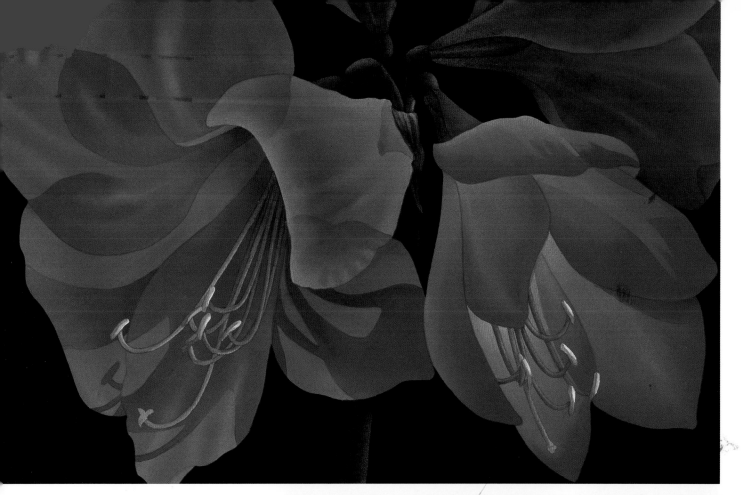

Ann Salisbury
Inner Glow
20" x 15" (50.8 cm x 38.1 cm)
Arches 140 lb. cold press
Media: Acrylic, watercolor, gouache

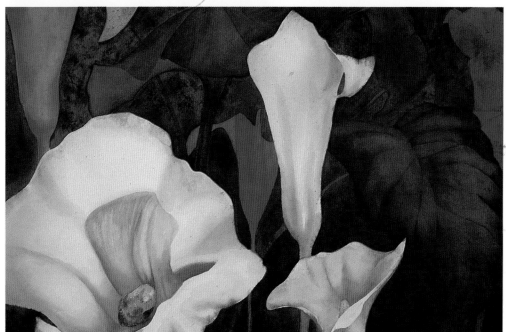

Patricia A. Hicks
Midnight Callas
15" x 22" (38.1 cm x 55.9 cm)
Arches 140 lb. cold press

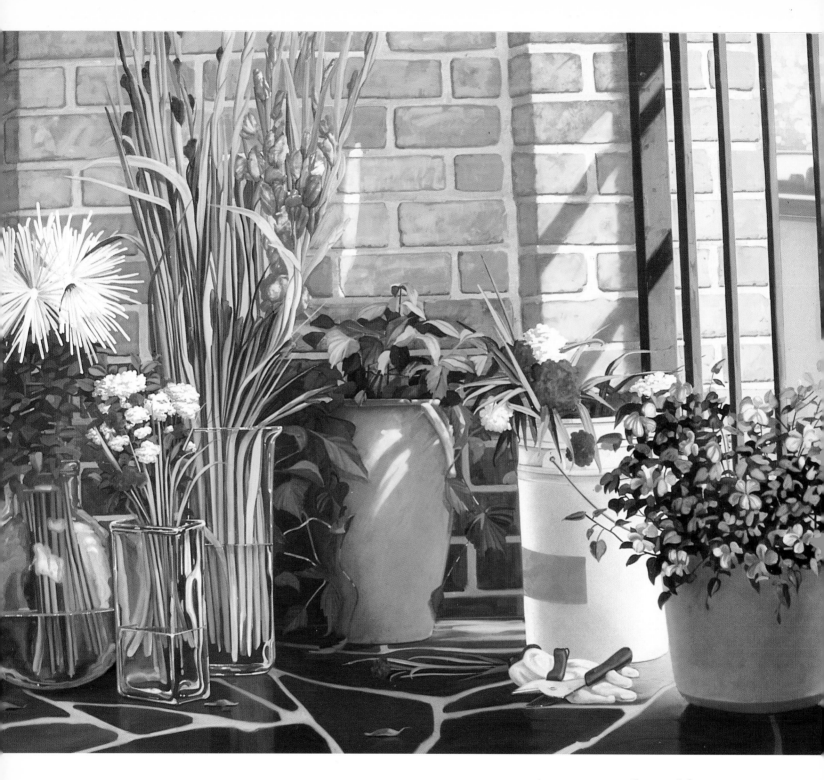

Gregory Johnson
Patio Reflections
35" x 45" (88.9 cm x 114.3 cm)
Ultrasmooth cotton duck

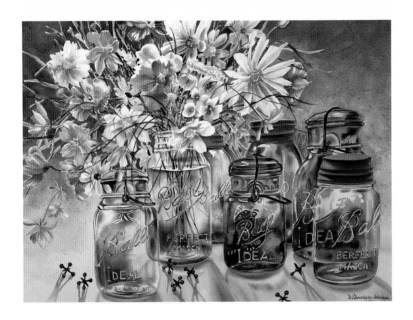

DJ Donovan-Johnson
Ball and Jacks
22" x 30" (56 cm x 76 cm)

Angelis Jackowski
Flor de Junio
48" x 48" (121.9cm x 121.9cm)
140 lb. Hot press

Mary Anne Staples
Light Illusions
22" x 30" (55.9cm x 76.2cm)
Arches 140 lb. hot press
Mixed media: Acrylic

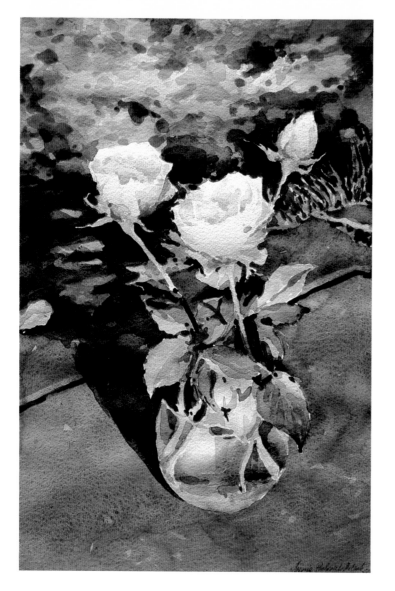

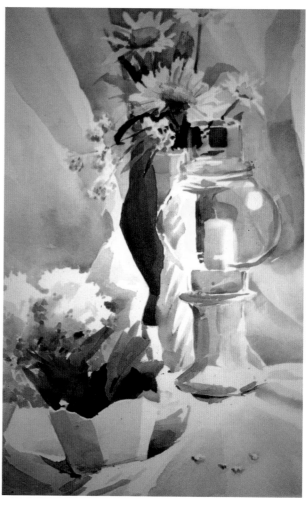

Marija Pavlovich McCarthy
Three Roses
15" x 22" (38.1 cm x 55.9 cm)
Fabriano Artistico 150 lb. rough

Jan Upp
White Still Life
20.75" x 13.5" (52.7cm x 34.3cm)
Arches 140 lb. cold press

William Pfaff
Calladiums on a Pink Table
19" x 25" (48.3 cm x 63.5 cm)
Gesso- and pumice-treated foam core

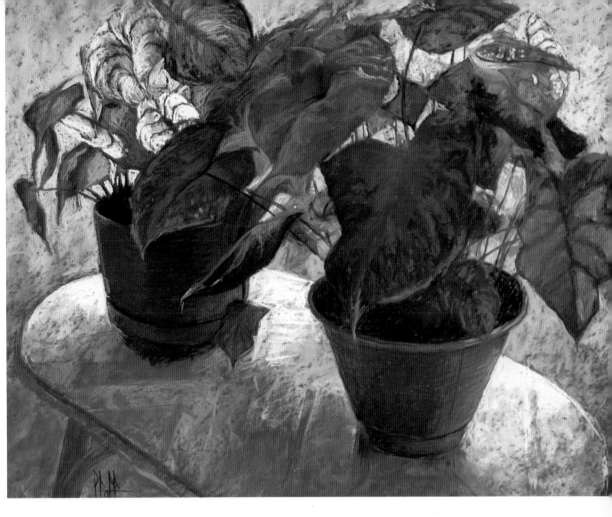

Marbo Barnard
Raku with Sumi Brush
23" x 18" (58.4 cm x 45.7 cm)
La Carte pastel card

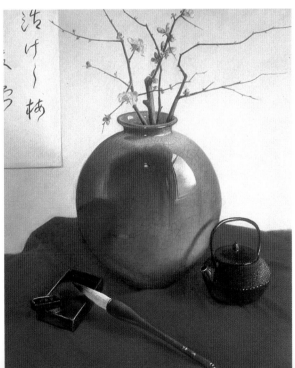

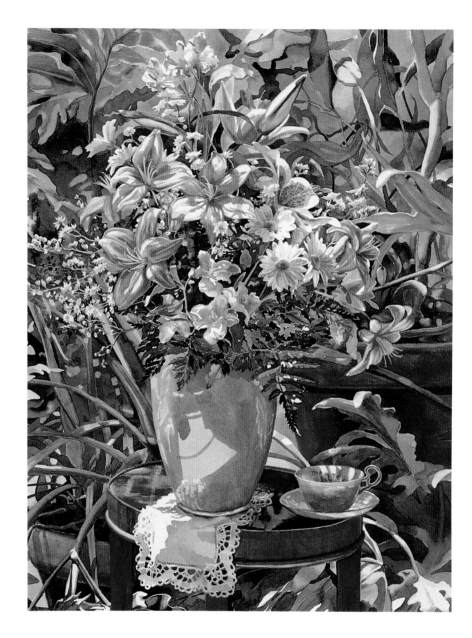

Liz Donovan
Lilies
22" x 35" (55.9cm x 88.9cm)
Arches 300 lb. watercolor paper

DJ Donovan-Johnson
Susan's Patio
22" x 30" (56 cm x 76)

Teresa Starkweather
Iris #10
30" x 40" (76.2cm x 101.6cm)
Arches 555 lb.

Karen B. Butler
Poppies
26" x 41" (66.0cm x 104.1cm)
Arches 260 lb. cold press

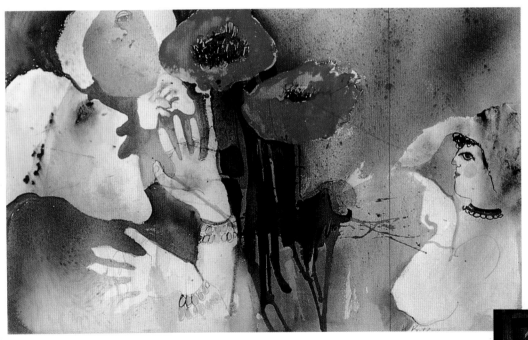

Mary Field Neville
Poppy Patterns
30" x 40" (76.2cm x 101.6cm)
Strathmore watercolor board cold press

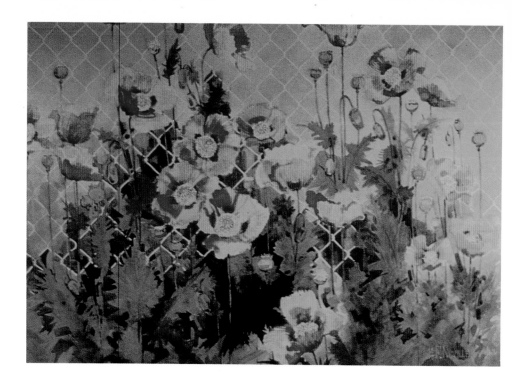

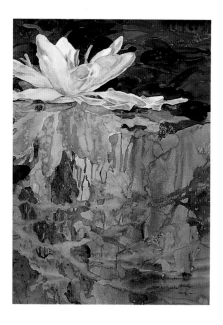

Elizabeth Hayes Pratt
Refraction
28" x 22" (71.1cm x 55.9cm)
Strathmore 3-ply all rag plate

Ann Pember
Peony Birth
14.5" x 21.5" (37 cm x 55 cm)
Waterford 140 lb. cold press

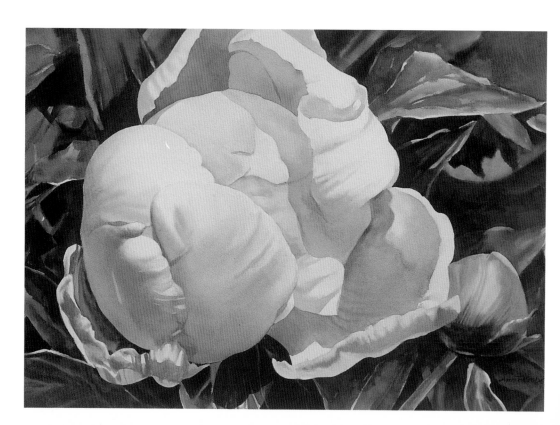

David R. Daniels
Blue Chair
45" x 35" (114.3cm x 88.9cm)
300 lb. Cold press

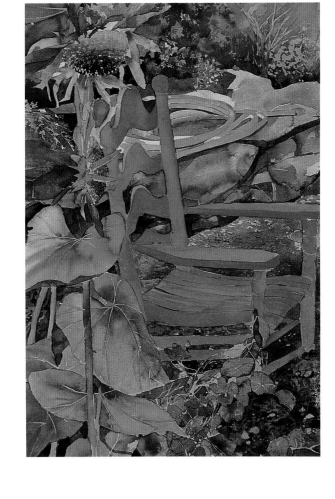

Rose Weber Brown
Breakthrough
22" x 30" (55.9cm x 76.2cm)
Crescent watercolor board #114

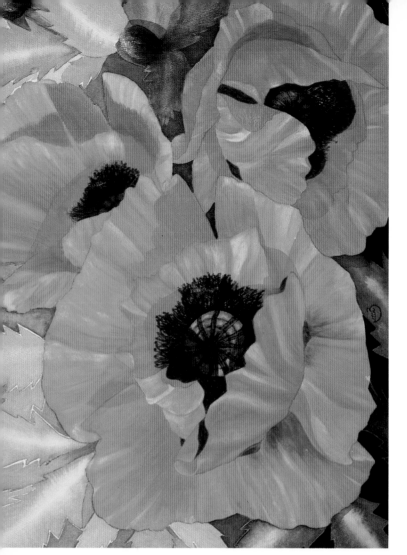

Zetta Jones
Taos Poppies
22" x 30" (55.9cm x 76.2cm)
Arches 300 lb. rough paper

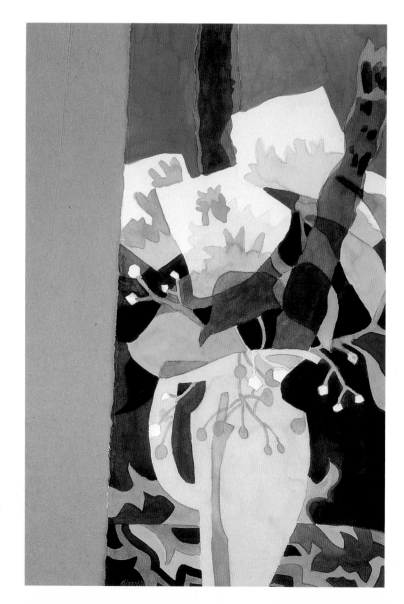

Joanna Mersereau
Snowballs
28" x 14" (71cm x 36 cm)
Saunders 300 lb. cold press

Thelma Davis
Silver Anniversary
20" x 16" (50.8 cm x 40.6 cm)
La Carte 200 lb. pastel card

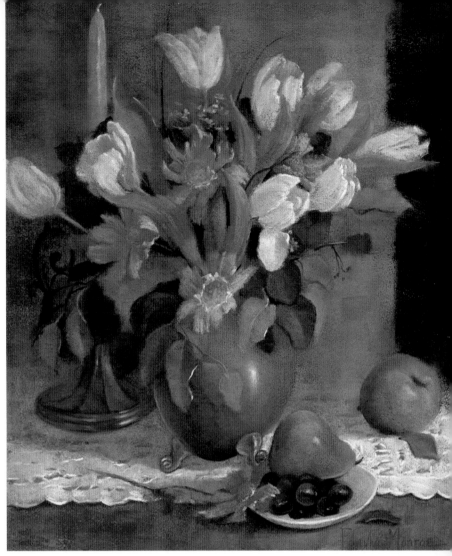

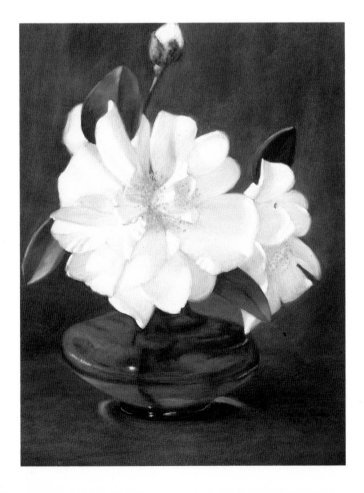

Flavia Monroe
White Tulips
24" x 20" (61 cm x 50.8 cm)
Pastel cloth

DJ Donovan-Johnson
Hollyhocks
30" x 22" (76 cm x 56 cm)

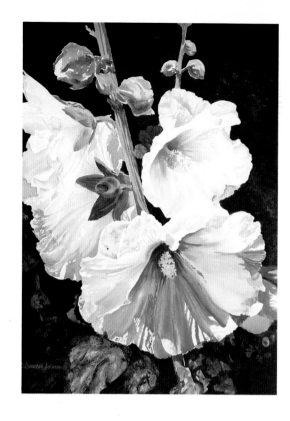

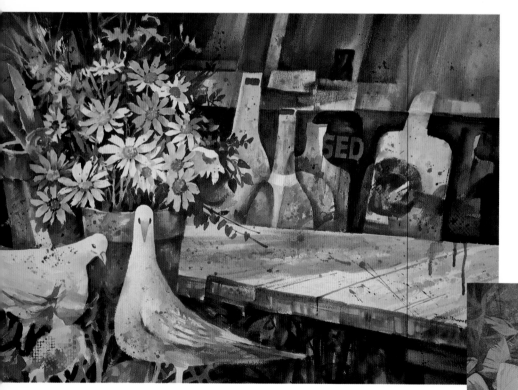

Cynthia L. Wilson
Vines
15" x 22" (38.1cm x 55.9cm)
Arches 140 lb. cold press
Mixed media: Acrylic layered washes

Jorge Bowenforbes, A.W.S., N.W.S.
Sentinels
29" x 42" (73.7cm x 106.7cm)
Strathmore watercolor board #112

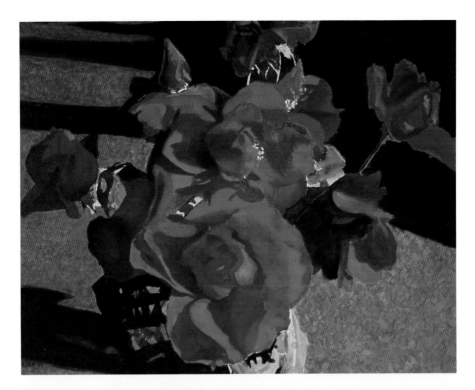

William Vasily Singelis
Red Roses
34" x 39" (86.4 cm x 99.1 cm)
Illustration board

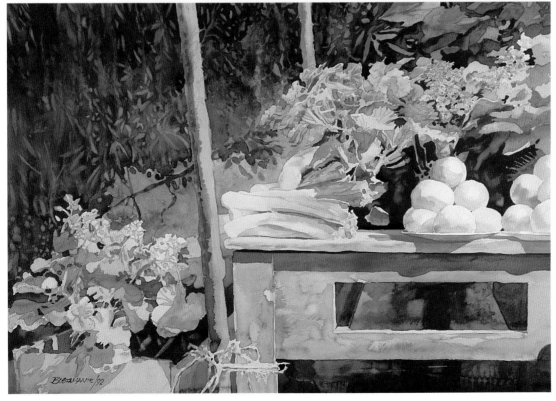

Jorge Bustamante
Survivors
28" x 20" (71.1 cm x 50.8 cm)
Guarro 140 lb

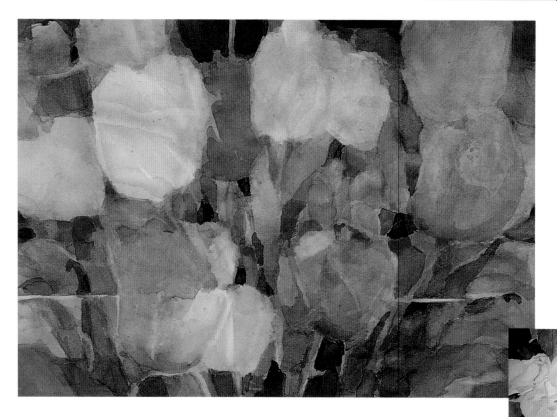

DJ Donovan-Johnson
Patio Series VIII
22" x 30" (56 cm x 76 cm)

Pat Fortunato
Alyeska Begonia II
22" x 30" (55.9cm x 91.4cm)
Waterford 140 lb. cold press

Madeliene Vallier
Variation on a Theme
24.25" x 17.25" (61.5cm x 44cm)
Arches 140 lb. cold press

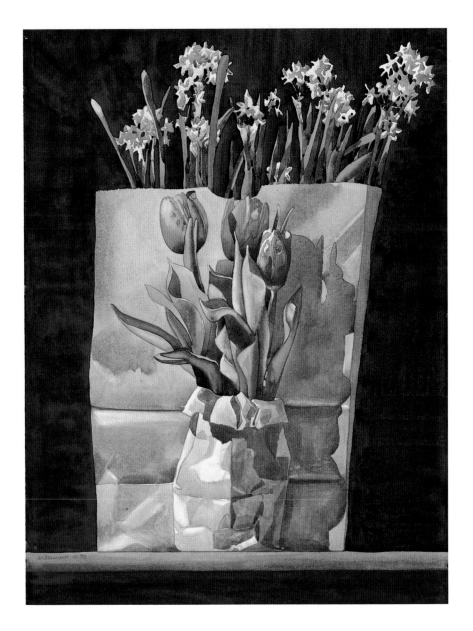

Williamarie Huelskamp
Spring in a Bag
22" x 30" (55.9cm x 76.2cm)
Lana Aquarelle 300 lb.

Joyce Gow, M.W.S. 69
901 11th Avenue
Two Harbors, MN 55616

Martha Cardot Griener 39
2409 Stratford Road
Delaware, OH 43015

Mary Griffin, N.E.W.S. 49
1002 Oakwood Street Ext.
Holden, MA 01520

Jeannie Grisham 68
10044 Edgecombe Place NE
Bainbridge Island, WA 98110

Sheila T. Grodsky 48
940 West End Drive
Newton, NJ 07860

Agnes Harrison 27, 46
309 Shannon Circle, 45th Street NW
Bradenton, FL 34209

Janet Heaton 62
1169 Old Dixie Highway
Lake Park, FL 33403

Patty Herscher 32
17 Catalpa Court
Fort Myers, FL 33919

Kathryn S. Heuzey 54, 65
121 Lawrence Hill Road
Cold Spring Harbor, NY 11724

Patricia A. Hicks 79
506 Sheridan Avenue
Marquette, MI 49855

Makie Hino 77
175 West 76th Street, #3G
New York, NY 10023

Mary G. Hobbs 44, 67
65 Carriage Stone Drive
Chagrin Falls, OH 44022

Jane R. Hofsetter 38
308 Dawson Drive
Santa Clara, CA 95051

Williamarie Huelskamp 93
482 Eleventh Avenue
Salt Lake City, UT 84103

Mary Sorrows Hughes 42
1045 Erie Street
Shreveport, LA 71106

Alice Bach Hyde 10
110 Ichabod Trail
Longwood, FL 32750

Angelis Jackowski 81
2556 Breckenridge Drive
Ann Arbor, MI 48103

D. Thornburg James 13
6700 E. 6th Avenue Parkway
Denver, CO 80220

Gregory Johnson 80
965 Timberlake Trail
Cumming, GA 30131

Zetta Jones 80
105 North Union Street #6
Alexandria, VA 22314

Lola Juris 16. 20
3200 Buena Hills Drive
Oceanside, CA 92056-3942

Kathleen Kalinowski 23
9120 Nestor NE
Comstock Park, MI 49321

Nordia Kay 30
145 Humphrey Street
Marblehead, MA 01945

Carole Katchen 72
624 Prospect Avenue
Hot Springs, AR 71901

Martha Kellar 75
3 Robin Lane
La Luz, NM 88337

Sue Kemp, S.W.S., T.W.S. 52
8102 Greenslope Drive
Austin, TX 78759

Connie Kuhnle 66
10215 Young Avenue
Rockford, MI 49341

Kristy A. Kutch 58
11555 W. Earl Road
Michigan City, IN 46360

Toni Lindahl 66
2120 New Garden Road
Greensboro, NC 27410

Gregory Litinsky, N.W.S. 68
253 W 91 Street, #4C
New York, NY 10024

Mary Lizotte 60
P.O. Box 93
Norwell, MA 02061

David Maddern 28
6492 SW 22nd Street
Miami, FL 33155

Mary Jane Manford 46
1602 Pease Road
Austin, TX 78703

Agnes Manning 29
12 Ashbrook Drive
Hampton, NH 03842

Benjamin Mau, N.W.S. 41
1 Lateer Drive
Normal, IL 61761

Marija Pavlovich McCarthy 82
393 Weekeepeemee Road
Woodbury, CT 06798

Joanna Mersereau 24, 88
4290 University Avenue #14
Riverside, CA 92501-3142

Linda M. Miller 75
1642 NE 127th Avenue
Portland, OR 97230

Vera Susan Miller 8
7212 Fairbanks Road
Hixson, TN 37343

Flavia Monroe 43, 89
2605 Rollingwood
Austin, TX 78746

Gloria Moses 14, 23
2307 Bagley Avenue
Los Angeles, CA 90034

Georgia A. Newton 59
1032 Birch Creek Drive
Wilmington, NC 28403

Mary Field Neville 86
307 Brandywine Drive
Old Hickory, TN 37138-2105

Nathalie Nordstrand, A.W.S. 11
384 Franklin Street
Reading, MA 01867

Diane J. O'Brien 76
17135 Beverly Drive
Eden Prairie, MN 55347

Directory & Index

Tim O'Neal 51
120 Pleasantview Drive
Hamilton, IL 62341

Laura Ospanik 78
1200 Western Avenue, #17-G
Seattle, WA 98101

Carolyn H. Pedersen, N.W.S. 73
119 Birch Lane
New City, NY 10956

Ann Pember 35, 37, 86
14 Water Edge Road
Keeseville, NY 12944

William Pfaff 83
5417 Courtland Road
Springfield, TN 37172

Mary Pohlmann 31, 67
15398 NE 2nd Avenue
Miami, FL 33162

Patricia Hough Pollard 71
6426 White Oak Road
Columbia, SC 29206

Elizabeth Hayes Pratt 86
P.O. Box 238
Eastham, MA 02642

Mitsuno Ishii Reedy 50
1701 Denison Drive
Norman, OK 73069

Ann Salisbury 70, 79
7300 Tanbark Way
Raleigh, NC 27615

Margaret Scanlan, A.W.S., W.H.S. 59
1501 Campbell Station Road
Knoxville, TN 37932

Terry Sciko 21
1450 Bonnie Road
Macedonia, OH 44056

Judith Scott 17
6658 South Gallup
Littleton, CO 80120

C. Patricia Scott 74
743 24th Square
Vero Beach, FL 32962

Suzanne Shedosky 40
1120 Hamilton Road
Rock Falls, IL 61071

Lois Showalter 53
231 R. Granite Street
Rockport, MA 01966

Kathy Shumway-Tunney 63
105 Walnut Street
Bordentown, NJ 08505

Sherry Silvers 68
405 Shallow Brook Drive
Columbia, SC 29223

William Vasily Singelis 91
25801 Lakeshore Boulevard #132
Euclid, OH 44132-1132

Linda L. Spies 65
919 Coulter Street
Fort Collins, CO 80524

Dixie Smith 12
25601 16th Avenue S.
Des Moines, WA 98198

Teresa Starkweather 85
1801 Chart Trail
Topanga, CA 90290

Mary Anne Staples 81
1930 East Gonzalez Street
Pensacola, FL 32501

Donna Stallard 56
413 South O'Connor
Irving, TX 75060

Hilda Stuhl 73
10559A Ladypalm Lane
Boca Raton, FL 33498

Patricia Suggs 72
4127 Beebe Circle
San Jose, CA 95135-1010

Jeannine Swarts 31
3741 S. Sunnyfield Drive
Copley, OH 44321

Nedra Tornay, N.W.S. 42
2131 Salt Air Drive
Santa Ana, CA 92705

Susan Webb Tregay 9
470 Berryman Drive
Snyder, NY 14226

Jan Upp 82
7335 Shadbleau
Jenison, MI 49428

Madeliene Vallier 92
2240 Rivenoak Court
Ann Arbor, MI 48103

Claire Schroeven Verbiest 26
3126 Brightwood Court
San Jose, CA 95148

Sibylla Voll 56
2938 Avenida Theresa
Carlsbad, CA 92009

Janet B. Walsh, A.W.S. 55, 69
130 W. 80 2R
New York, NY 10024

Wolodimira Vera Wasiczko 47
5 Young's Drive
Flemington, NJ 08822

Betty Welch 33
4364 Newbury Drive
New Port Richey, FL 34652

Cynthia L. Wilson 35, 90
107 Beachview Drive
Mooresville, NC 28115

Madlyn-Ann C. Woolwich 10
473 Marvin Drive
Long Branch, NJ 07740-5003

Ruth Wynn, A.W.S. 69
30 Oakledge Road
Waltham, MA 02154

Maxine Yost 9
915 West B
North Platte, NE 69101

Frank E. Zuccarelli 11
61 Appleman Road
Somerset, NJ 08873